LOOKING AT ART

THE ART OF LOOKING

LOOKING AT ART

THE ART OF LOOKING

Foreword by Malcolm Margolin

LOOKING AT ART

THE ART OF LOOKING

Photographs by Richard Nagler

HEYDAY, BERKELEY, CALIFORNIA

Library of Congress Cataloging-in-Publication Data

Nagler, Richard.

 [Photographs. Selections]

 Looking at art, the art of looking / photographs by Richard Nagler; foreword by Malcolm Margolin.

 pages cm

 ISBN 978-1-59714-266-3 (softcover : alk. paper) — ISBN 978-1-59714-268-7 (hardcover : alk. paper)

 1. Photography of art. 2. Museum visitors—Portraits. 3. Art appreciation. I. Title.

 TR657.N34 2014

 779.092—dc23 2013036951

Cover Art: Pablo Picasso, *Les Demoiselles d'Avignon* (1907), Museum of Modern Art, New York, photograph by Richard Nagler

Cover and Interior Design/Typesetting: Leigh McLellan Design

Orders, inquiries, and correspondence should be addressed to:

 Heyday

 P.O. Box 9145, Berkeley, CA 94709

 (510) 549-3564, Fax (510) 549-1889

 www.heydaybooks.com

Printed in China by Imago

10 9 8 7 6 5 4 3 2 1

FOREWORD

Malcolm Margolin

To write an introduction to a Richard Nagler book is to join an exclusive club. Isaac Bashevis Singer, the great Yiddish writer, wrote the introduction to his first book, *My Love Affair with Miami Beach* (Simon and Schuster, 1991). This tender, joyful book of photographs shows elderly Jewish immigrants, mostly born in the impoverished shtetls of Eastern Europe, some with concentration camp numbers tattooed on their arms, cavorting in the tropical, sensual fecundity of Miami's beaches and parks. Only a writer with Singer's depth of soul could embrace the contradictions of a world so lovingly rendered by Nagler's photos, a world in which the Ultra-Orthodox in crow-black gabardine share space with topless models, where *schuls* are nestled between art deco buildings, where warm ocean waters dissolve the pain of aging and lap away at bitter memory.

In Richard's second book, *Oakland Rhapsody* (North Atlantic Books, 1995), photographs look not at but through the poverty and decay of Oakland to reveal layers of poignant beauty and salvation. This book was introduced by Ishmael Reed, a well-known novelist, cultural activist, and social critic, and himself a resident of Oakland. Reed was a finalist for the Pulitzer, twice nominated

for the National Book Award, winner of a MacArthur Foundation Genius Grant, and founder of the Before Columbus Foundation and Oakland PEN. Reed is a cultural hero, his love of Oakland a smoldering fire.

Peter Selz introduced Nagler's third book, *Word on the Street* (Heyday, 2010). This book paired isolated words found on the street with passersby whose accidental collision with the word was at times profoundly moving, other times fantastically funny, often both at the same time. Selz is a prolific author and former chief curator of the Department of Painting and Sculpture at the Museum of Modern Art in New York. He went on to found the University of California Art Museum in Berkeley, is highly regarded in art circles, and has the breadth of knowledge to put Nagler's photography into the context of international artistic movements throughout the last century.

With a string of such illustrious predecessors, why did Richard turn to me for this introduction? I have neither renown nor specialized knowledge. But I do have a reservoir of delight in the photographs before us, and by living intimately with them for many months I've developed a deep familiarity. I'm the publisher of Heyday, and I was so taken by these photos that during the time when we were acquiring, editing, and designing the project, I kept a set of prints on a long table just outside my office. Everyone who came within hailing distance—authors, printers' reps, designers, program officers from foundations, even the UPS driver and mail carrier—would get dragged over to the table.

It was interesting to me that many people found the first photo they looked at a bit perplexing. We're not used to this egalitarian relationship between art object and viewer. If a person and a work of art are in the same photograph, we generally expect that one of them will be the focus of attention, the other background. But in these photos the artwork and the person share a stage as equals, in some cases almost like dance partners.

In these astounding encounters between art and viewer, there's often the feeling of a tryst, a secret meeting of lovers, and each of these "lovers" is amplified and changed by the experience. By echoing the imagery or theme of the artwork, the viewer in the photograph takes on some of the power of the art. Similarly, the artwork takes on added depth by its momentary association with the person viewing it. We see each of the participants—artwork and person—in a new light. Take, for example, the couple kissing in front of Van Gogh's *Starry Night*

(page 44). If you were to separate the passionate young couple from the fiery but paradoxically soothing painting, each—couple and painting—would have been masterful alone. Juxtaposed, there seems to be a harmony, a fullness, a rich complexity that enhances both the humans and the artwork. The couple and the painting both seem to have gained from their chance meeting.

As the people I dragged over to the table thumbed through the prints, I'd watch as something like a revelation moved through them. Worry lines melted from faces, laughter emerged, cares were shed, and a deep contentment spread. People walked away smiling and filled with wonder. It felt like Lourdes on a good day.

What makes these photos so appealing—indeed, so transformative? It's partly that many of them are so funny. Not funny as in mockery, but funny in such a warm, big-hearted way. It's similar to the feeling of delight and discovery when we see a person and his dog and notice the resemblance, the feeling of being privy to a secret, in on a joke. It's the intense joy of feeling in the mind something like an arc of electricity when the thoughts jump between two seemingly different objects and lock them together.

The photos in this book are all candid, not a one of them posed. I envision Richard in the museum, camera in hand, waiting perhaps hours for the right person to come by. And I find myself wondering: Could the work of art be waiting as well? Could it be that a work of art is not complete except when a viewer interacts with it? The world's greatest painting locked in a dark closet is nothing. Art needs human interaction, and that interaction gives the artwork added layers of meaning. I have a wonderful friend, Ernie Siva, a Serrano Indian from Southern California, who has been keeping alive a wide repertoire of traditional Serrano songs. Once, after singing an especially lovely song, I asked him what the song meant.

He thought for a minute, and answered. "If you want me to translate the words into English, I can do that. But that's not necessarily what the song means. What gives it meaning is who taught it to me, who I will teach it to, where it appears in the cycle of songs, whether we have sung it at a funeral and whose funeral, etc. Your asking me about the song likewise adds to its meaning."

The pairing of people and art creates wonderful and enriching narratives and layers of complexity. Take, for example, the image of the young woman in

blue shorts and an American flag shirt examining *Young Woman Sewing* by Renoir (page 36). The woman in the painting is looking at her sewing. Renoir was looking at the woman as he was painting her. The finished painting was hung at the Art Institute of Chicago, where the young woman in the blue shorts came to look at it. Off to the side and hidden from view, Richard Nagler looked at the woman and the painting and snapped the shutter. A print of the picture that Richard took was handed to book designer Leigh McLellan, who placed it within the book's layout and set it on the page. Diane Lee, Heyday's production editor, looked at where Leigh had placed it and prepared instructions for the printer. The printer, Imago, looked at Diane's instructions and provided color settings necessary to replicate the original as closely as possible. And now you, the reader of this book, are looking at the photo that the printer printed from Diane's instructions and Leigh's design of the photo that Richard took when he was looking at the girl in the blue shorts who was looking at the painting that Renoir did when he was looking at the woman looking at her sewing. There are stories within stories within stories, all together like sets of Russian *matryoshka* dolls, or perhaps, to use another metaphor, all linked together in the great daisy chain of life.

Yet for all the cumulative work and layers of complexity, there's an immediacy to these photos, a freshness of accident, a delight in the moment and a celebration of the fragile coincidence that brought into the same space a person and a piece of art, a once-in-a-lifetime, never-to-be-repeated phenomenon captured in a fraction of a second. The freshness and spontaneity are real enough, but they hide something else—a masterful sense of color and composition, a classical sense of structure that gives that spark of the moment a sense of inevitability and immortality that we find in the great masters of photographic and other visual arts. What is being captured here is fleeting and at the same time eternal, and looking at it stretches the mind in pure delight.

On a personal note, Richard Nagler and I both live and work in Berkeley, California. Every so often, we have lunch together. It's what publishers are supposed to do—go out to lunch. I do this part of my job well, but in truth Richard makes it especially easy. Lunch with him is such a joy! Wherever we go, he finds the food to be absolutely delicious, the waitress to be heart-stoppingly gorgeous, the company around the table the wisest, funniest, most compassionate people the world has ever seen. He sings the praises of the place and the people, hanging on as tightly as he can to the irreplaceable moment. Of all the people I know, I have never met anyone more keenly aware of beauties of the world, the brevity of life, and the remorseless passage of time.

A genuine and deep love of people shines in Richard, and it is this love that permeates the photos in this book and gives them such emotional depth. There is nothing gimmicky here, although the subject matter would lend itself to gimmick. There is not a drop of cruelty; mockery would have been easy. Despite all the reasons he shouldn't, Richard loves humanity, and these photos express homage to the beauty of the human adventure and the beauty of art. In a way he functions as a *shadkhn,* a marriage broker, does in traditional Jewish society. He sees a promising but lonely piece of art and initiates the search for the perfect mate. This book is a tribute to successful matchmaking. It is a wedding album, and we are guests at the wedding. Turn the pages and celebrate.

LOOKING AT ART

THE ART OF LOOKING

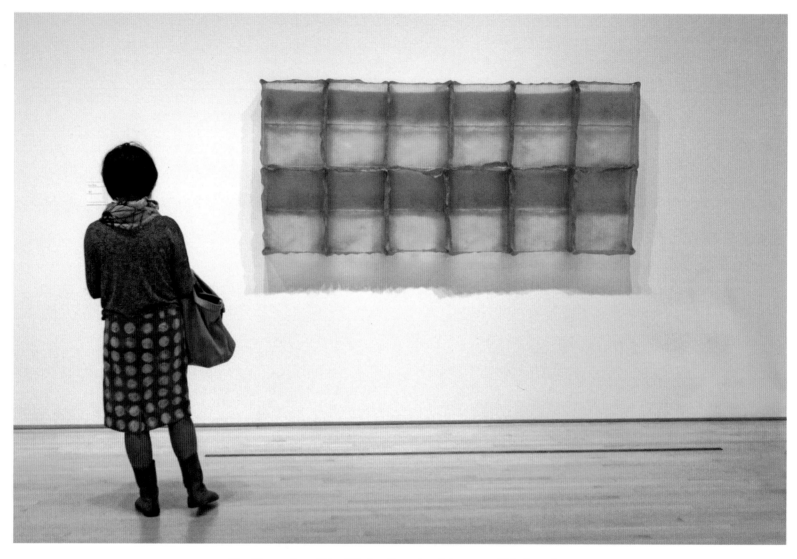

Eva Hesse, *Sans II* (1968), San Francisco Museum of Modern Art

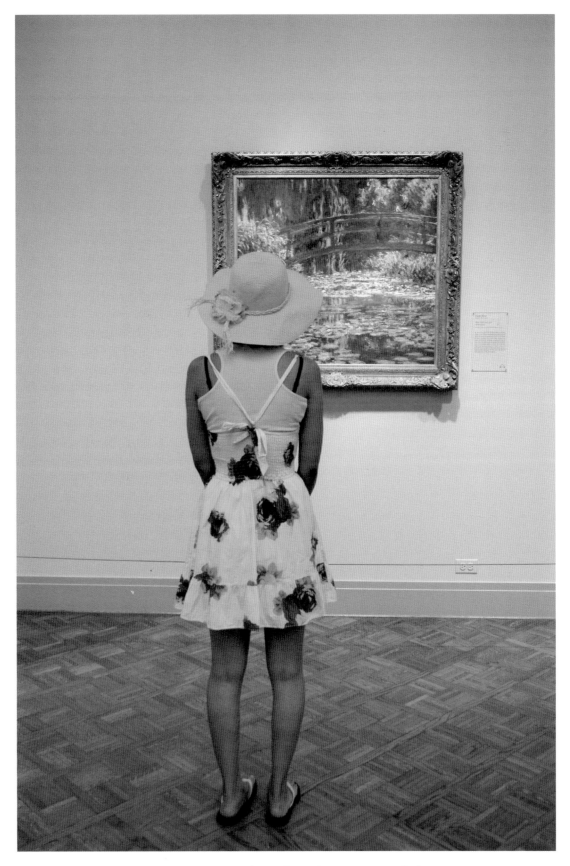

Claude Monet, *Water Lily Pond* (1900), Art Institute of Chicago

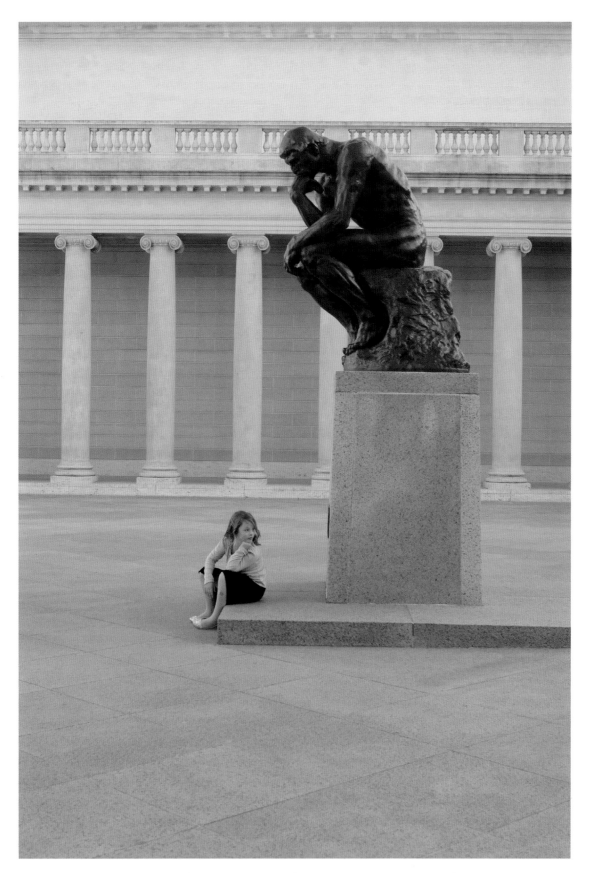

Auguste Rodin, *The Thinker* (1904), Legion of Honor, Fine Arts Museums of San Francisco

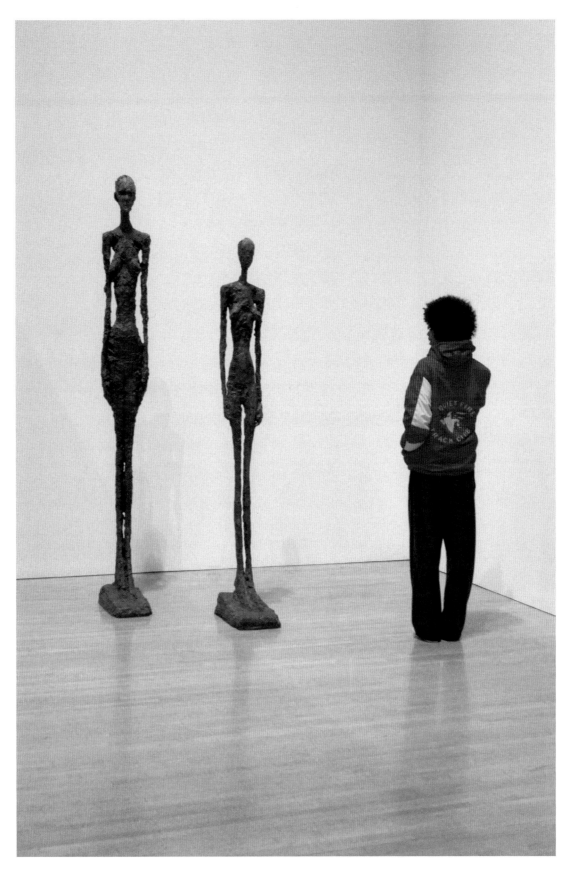

Alberto Giacometti, *Tall Figure II* and *Tall Figure III* (1960), Museum of Contemporary Art, Los Angeles

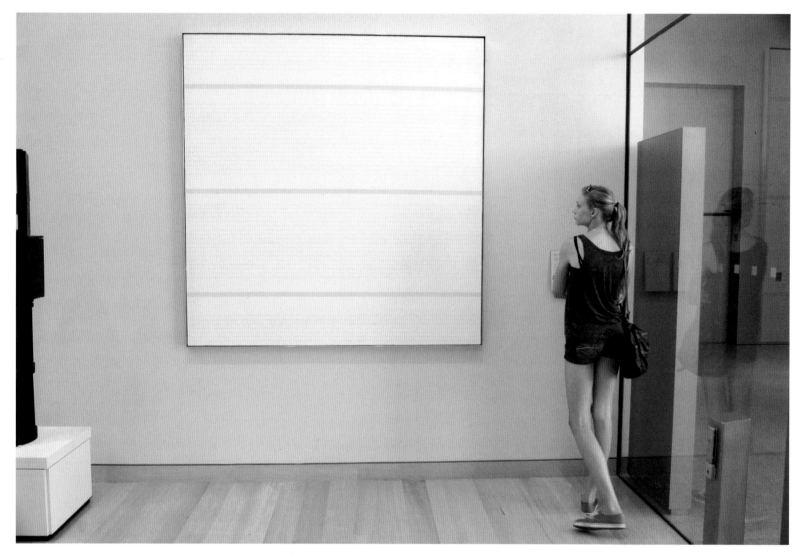

Agnes Martin, *Untitled #15* (1988), Museum of Fine Arts, Boston

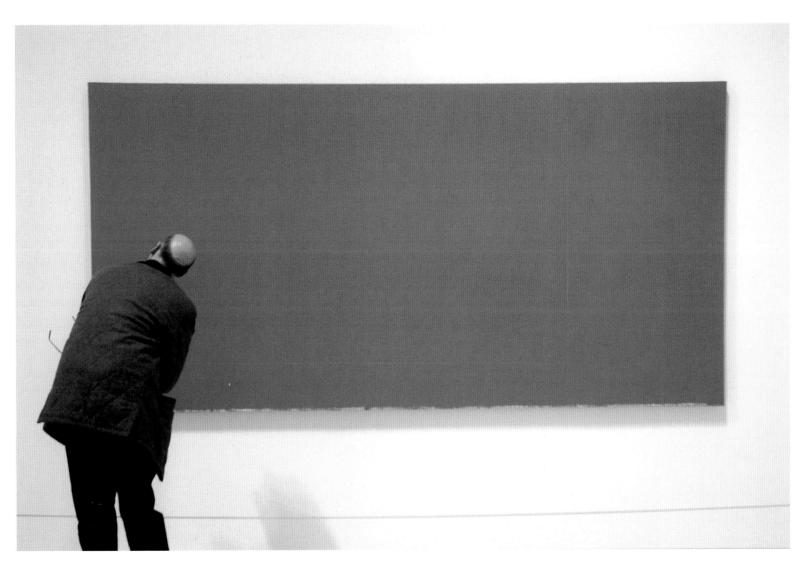

Brice Marden, *The Dylan Painting* (1966), San Francisco Museum of Modern Art

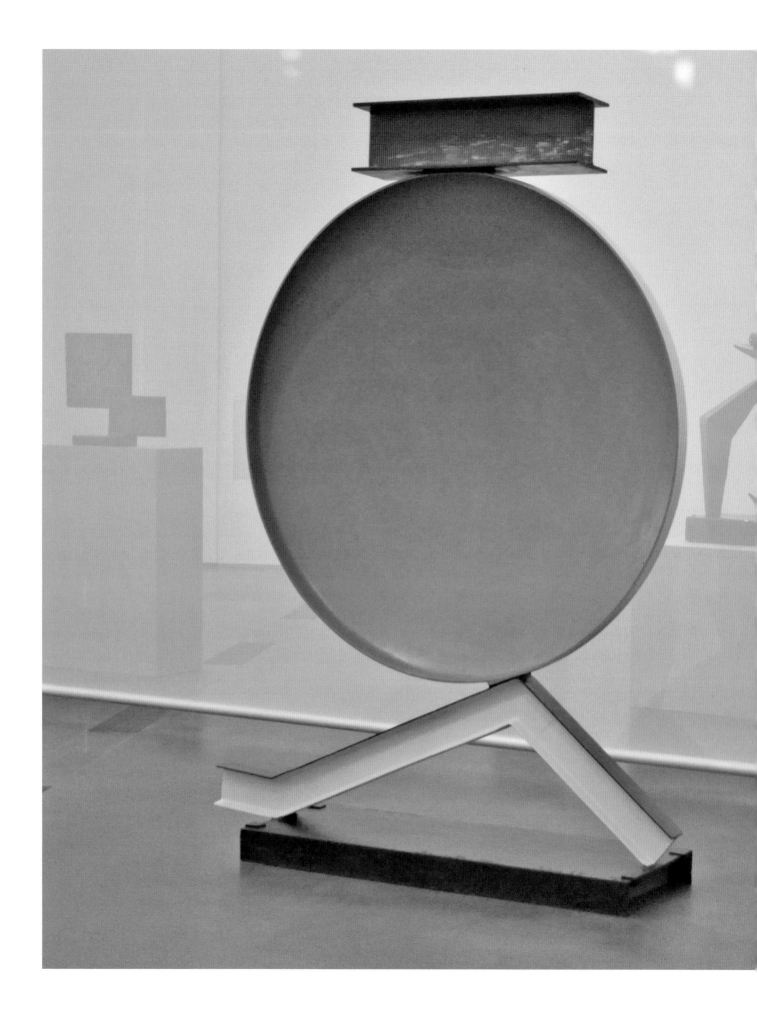

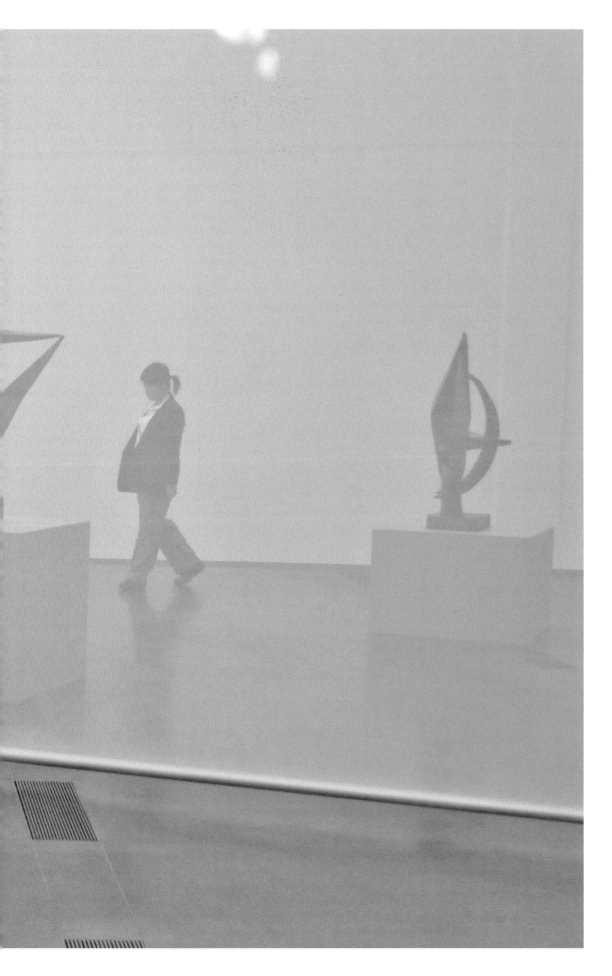

David Smith, *Bec-Dida Day* (1963),
Los Angeles County Museum of Art
(from the collection of
the Yale University Art Gallery)

9

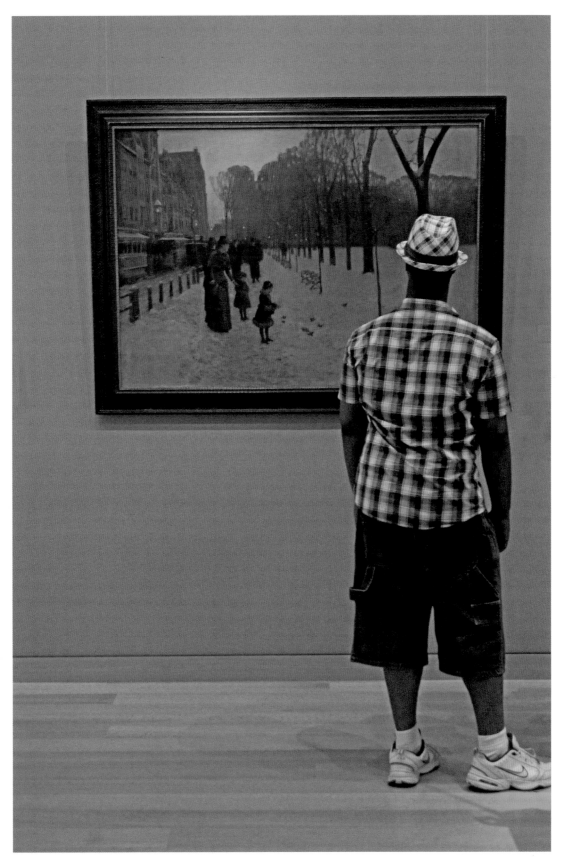

Childe Hassam, *Boston Common at Twilight* (1885–86), Museum of Fine Arts, Boston

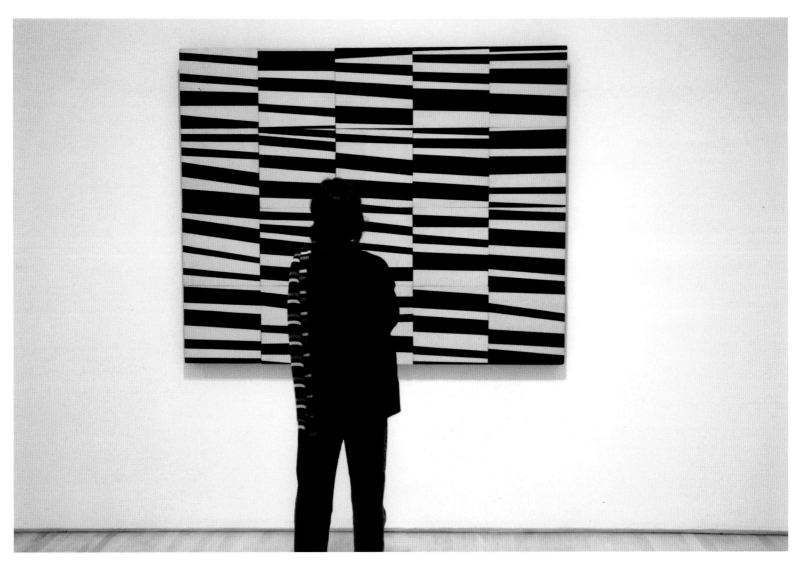

Ellsworth Kelly, *Cite* (1951), San Francisco Museum of Modern Art

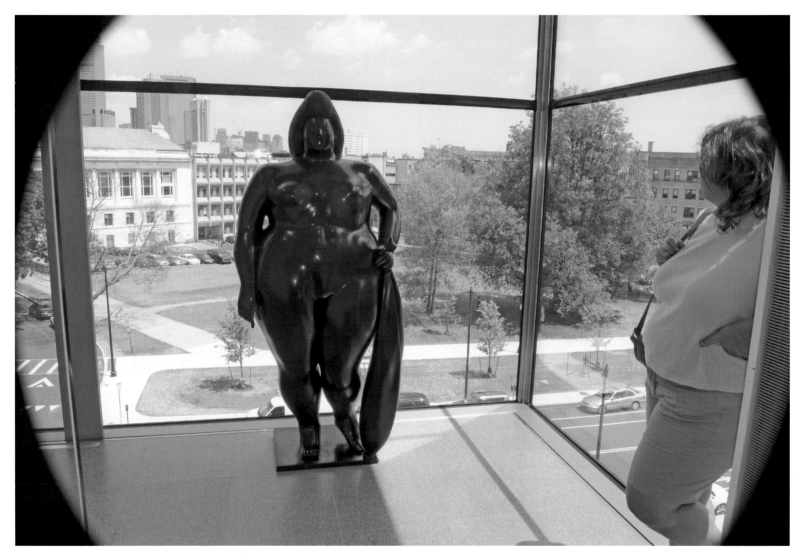

Fernando Botero, *Venus* (1977–78), Museum of Fine Arts, Boston

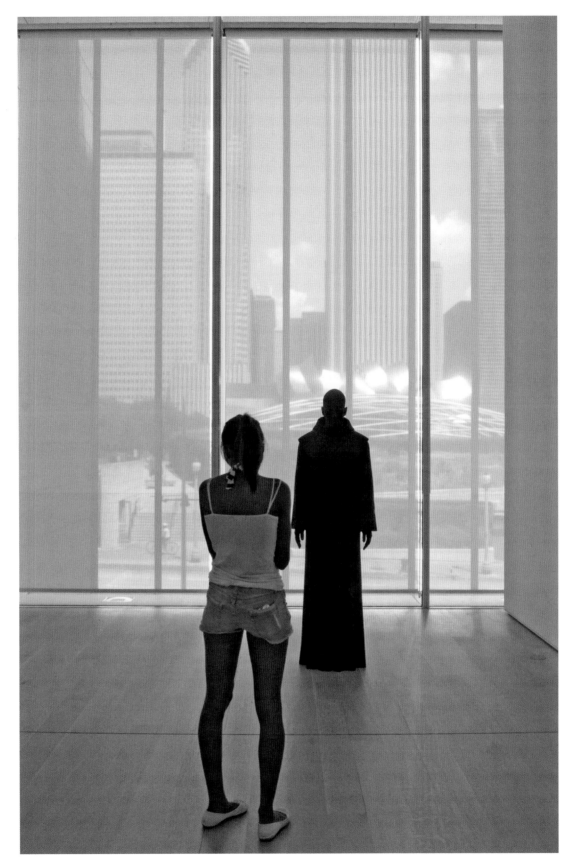

Katharina Fritsch, *Monk* (1997–99), Art Institute of Chicago

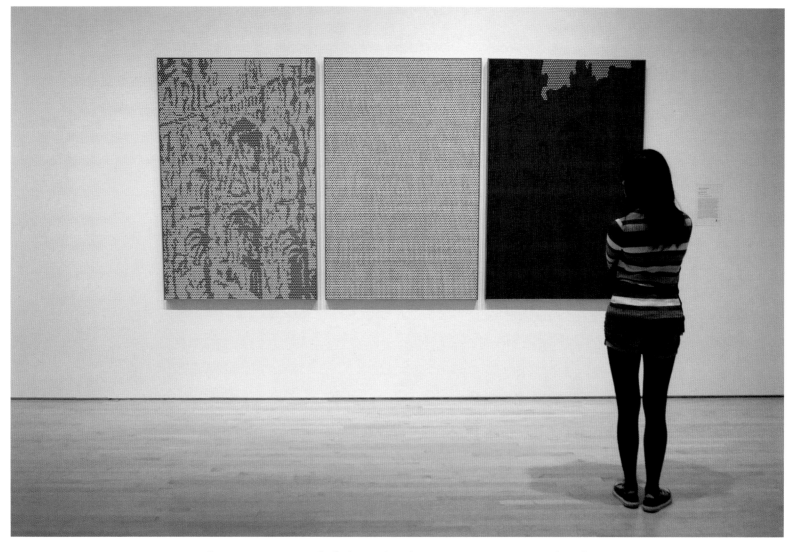

Roy Lichtenstein, *Rouen Cathedral Set V* (1969), San Francisco Museum of Modern Art

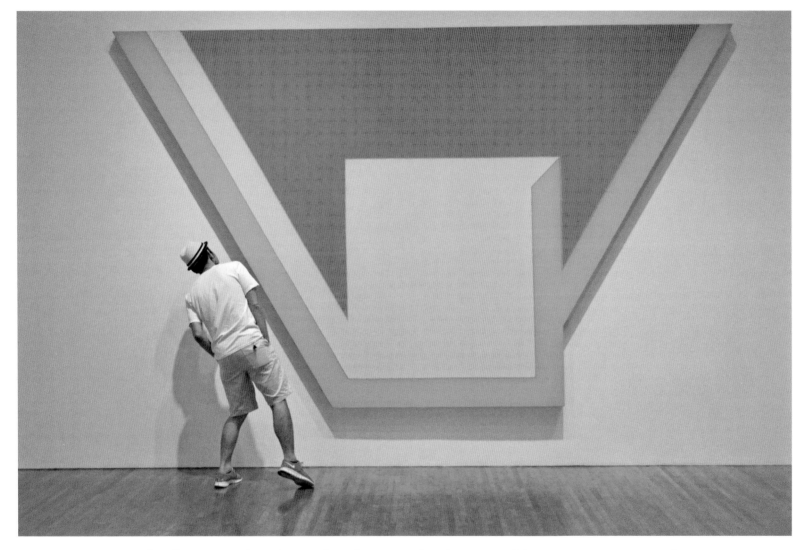

Frank Stella, *Union III* from the *Irregular Polygon* series (1966), Museum of Contemporary Art, Los Angeles

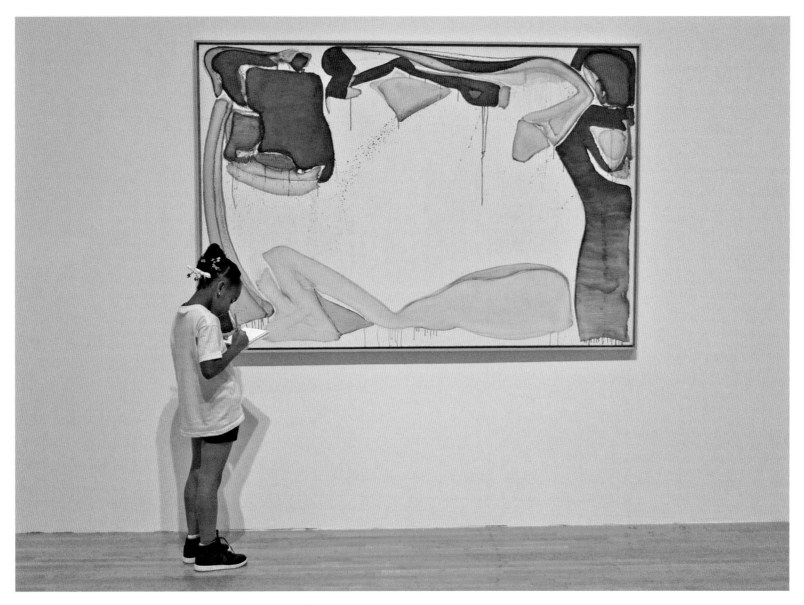

Sam Francis, *Mantis* (1961), Museum of Contemporary Art, Los Angeles

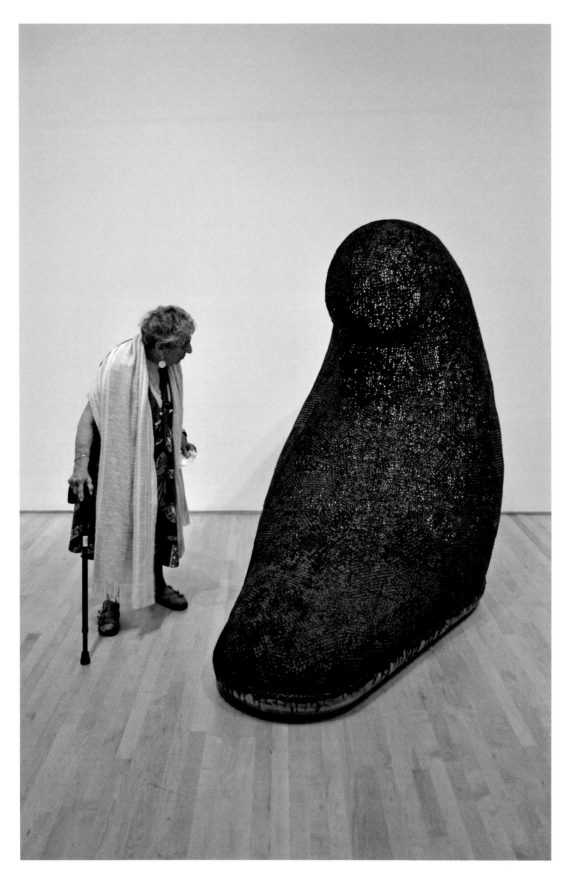

Martin Puryear, *Untitled* (1990), San Francisco Museum of Modern Art

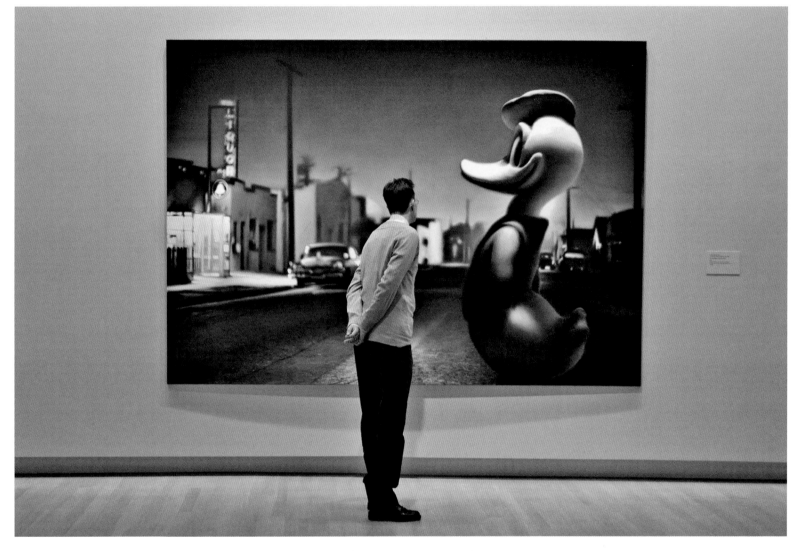

Gottfried Helnwein, *In the Heat of the Night* (2000), Crocker Art Museum, Sacramento

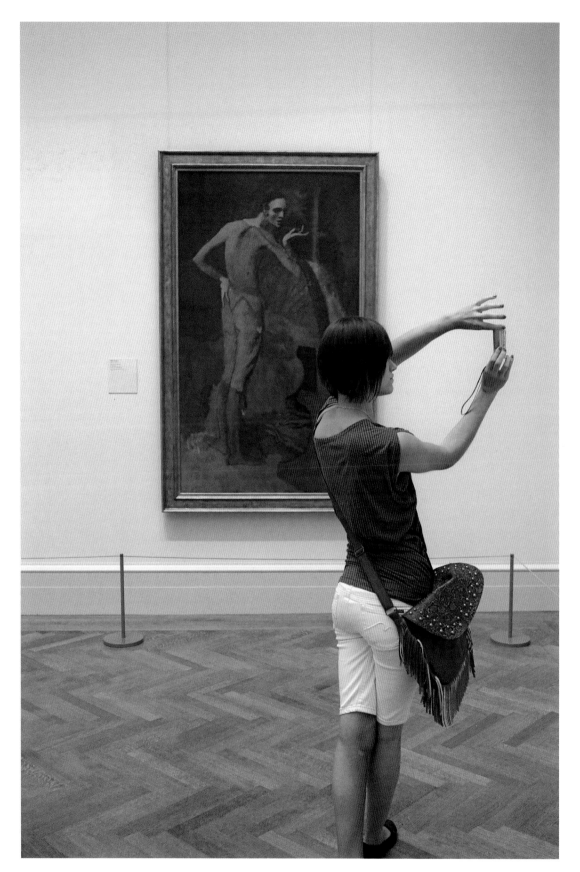

Pablo Picasso, *The Actor* (1904–05), Metropolitan Museum of Art, New York

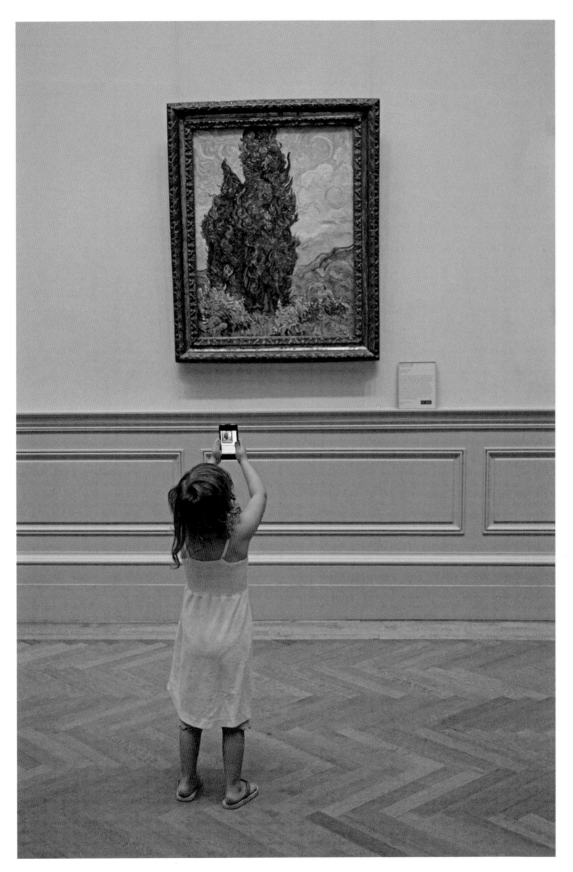

Vincent van Gogh, *Cypresses* (1889), Metropolitan Museum of Art, New York

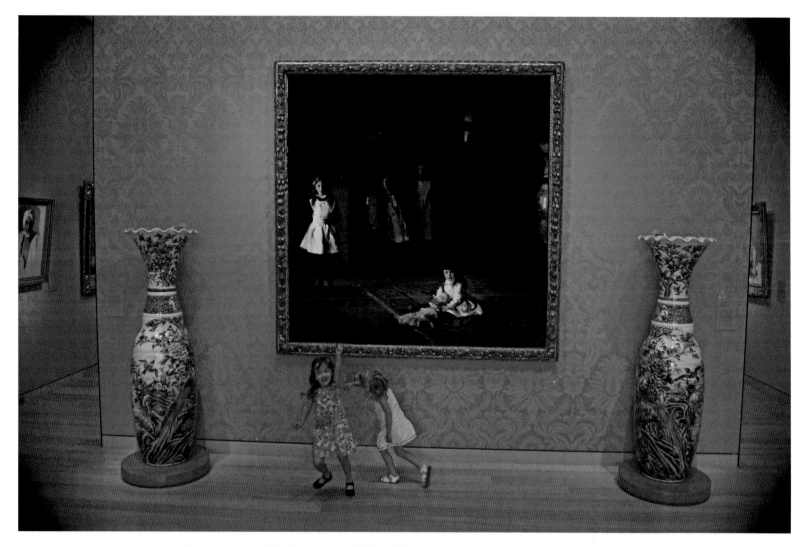

John Singer Sargent, *The Daughters of Edward Darley Boit* (1882), Museum of Fine Arts, Boston

Sebastiano Ricci, *Diana and Her Nymphs Bathing* (1713–15),
Royal Academy of Arts, London

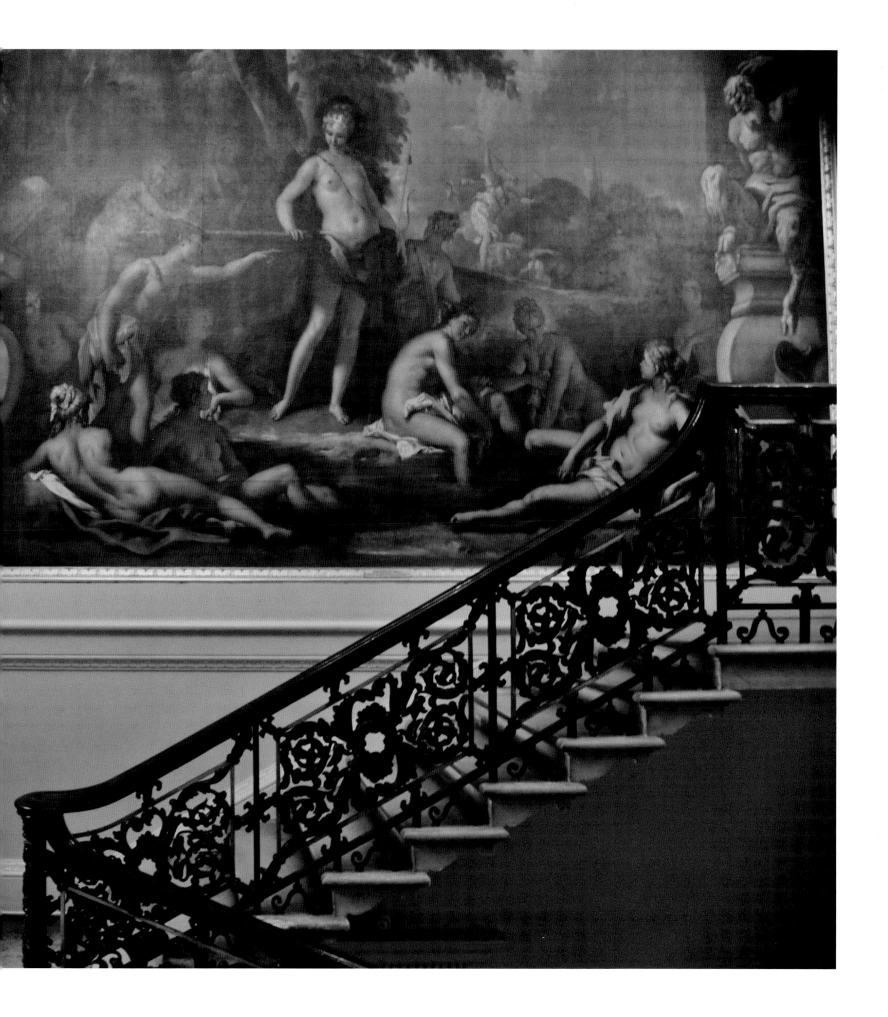

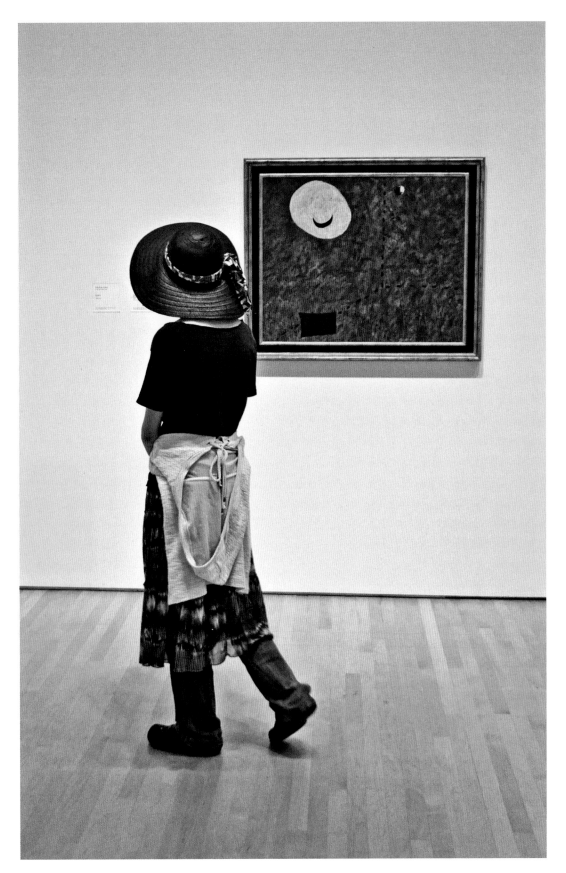

Joan Miró, *Peinture* (1926), San Francisco Museum of Modern Art

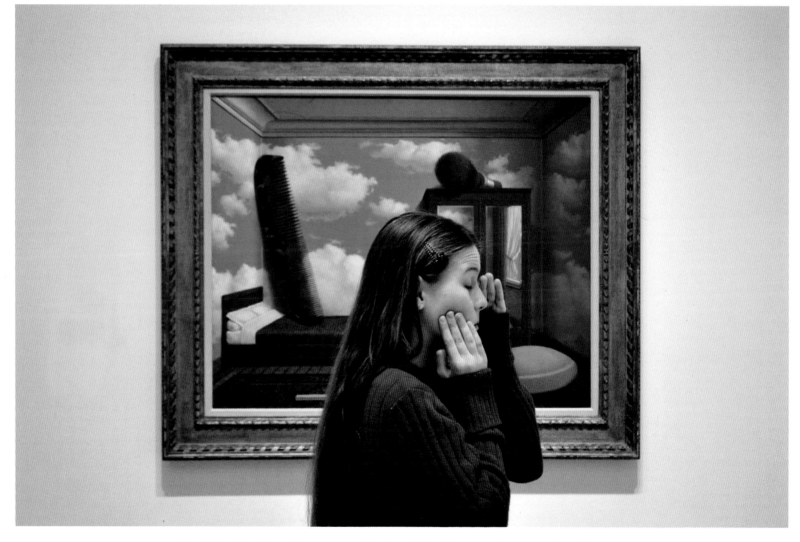

René Magritte, *Les valeurs personnelles* (1952), San Francisco Museum of Modern Art

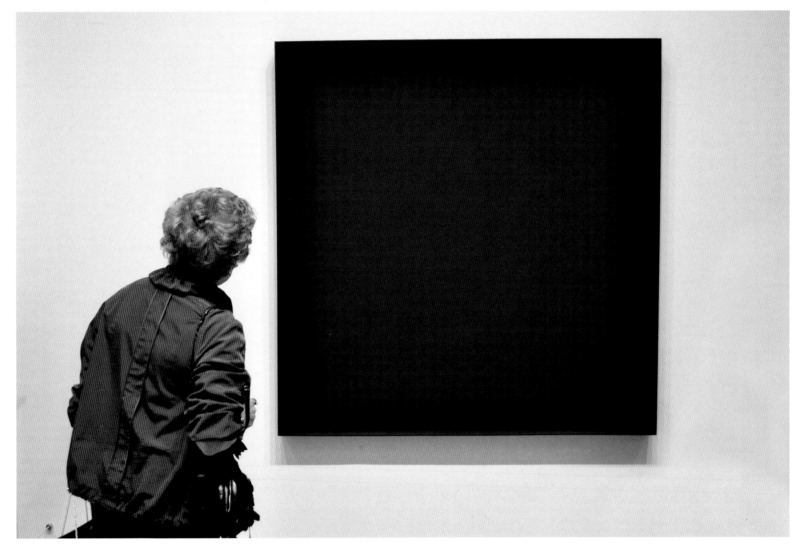

Ad Reinhardt, *Abstract Painting* (1960–61), Museum of Modern Art, New York

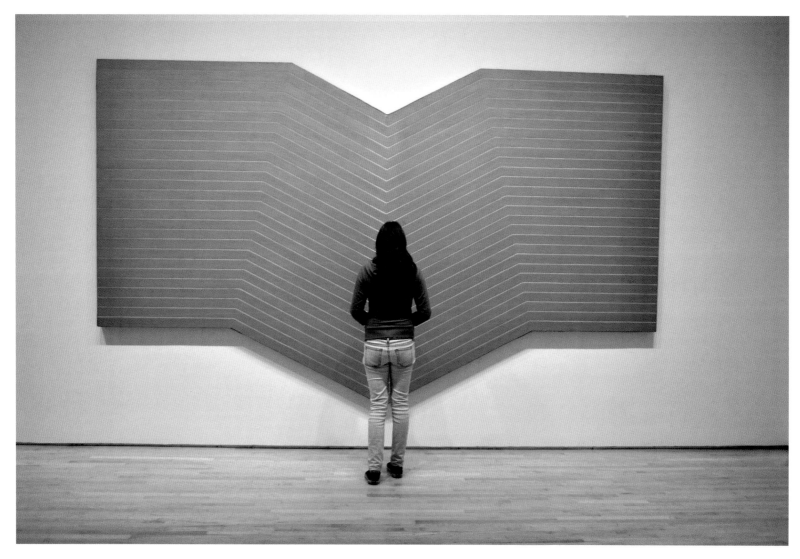

Frank Stella, *Adelante* (1964), San Francisco Museum of Modern Art

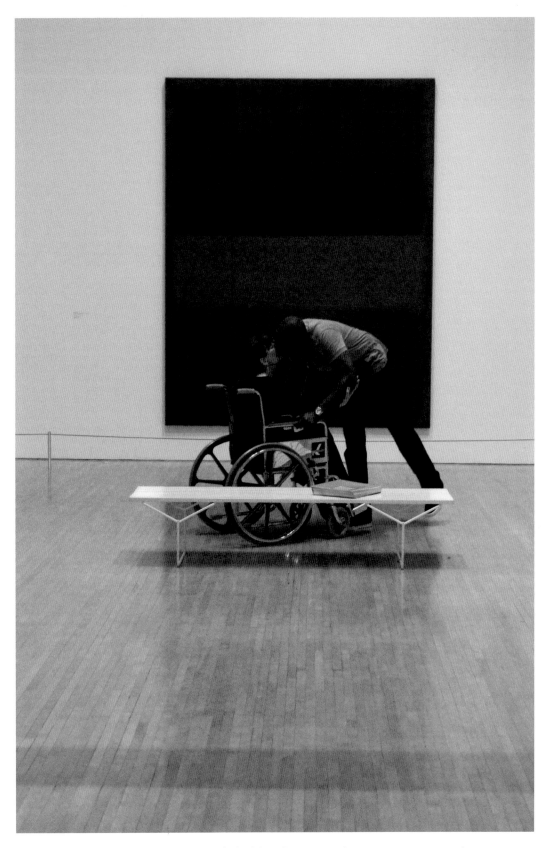

Mark Rothko, *No. 61 (Rust and Blue)* (1953), Los Angeles County Museum of Art
(from the collection of the Museum of Contemporary Art, Los Angeles)

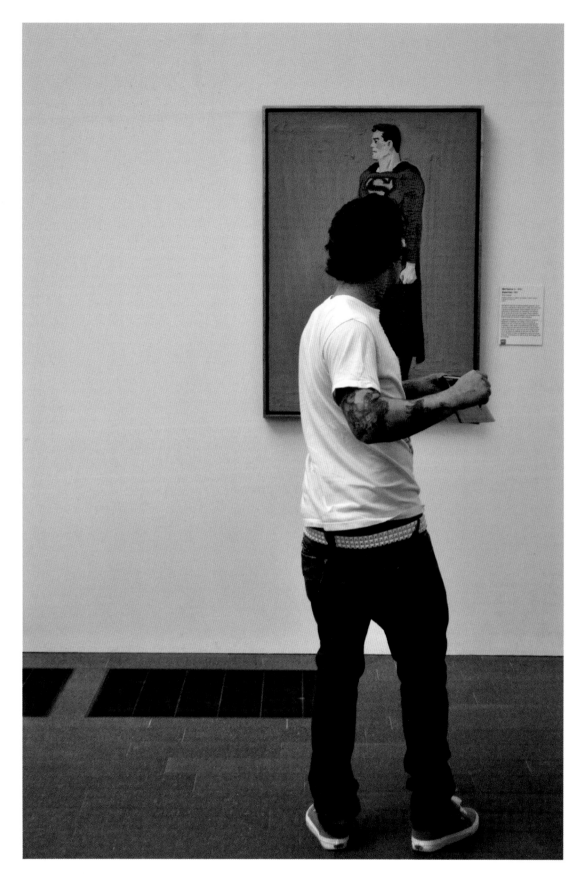

Mel Ramos, *Superman* (1962), de Young Museum, Fine Arts Museums of San Francisco

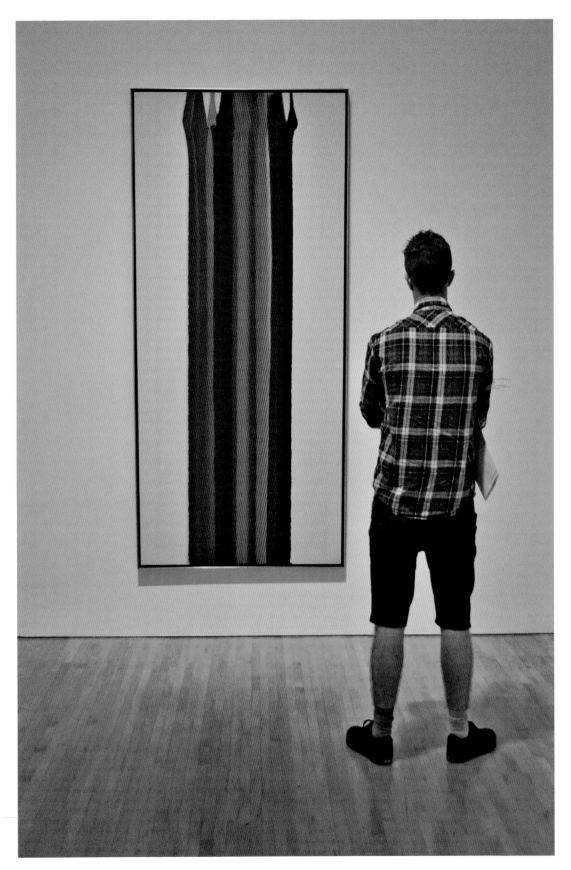

Morris Louis, *Pillar of Delay* (1961), Museum of Contemporary Art, Los Angeles

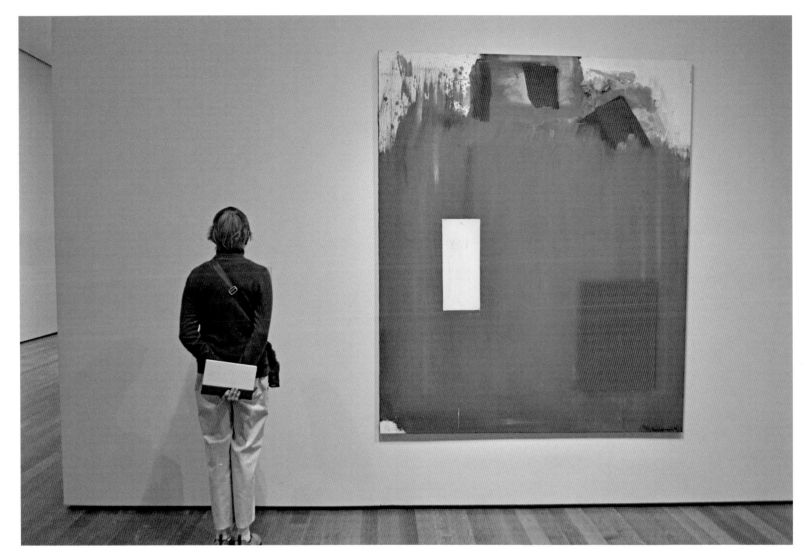

Hans Hofmann, *Memoria in Aeternum* (1962), Museum of Modern Art, New York

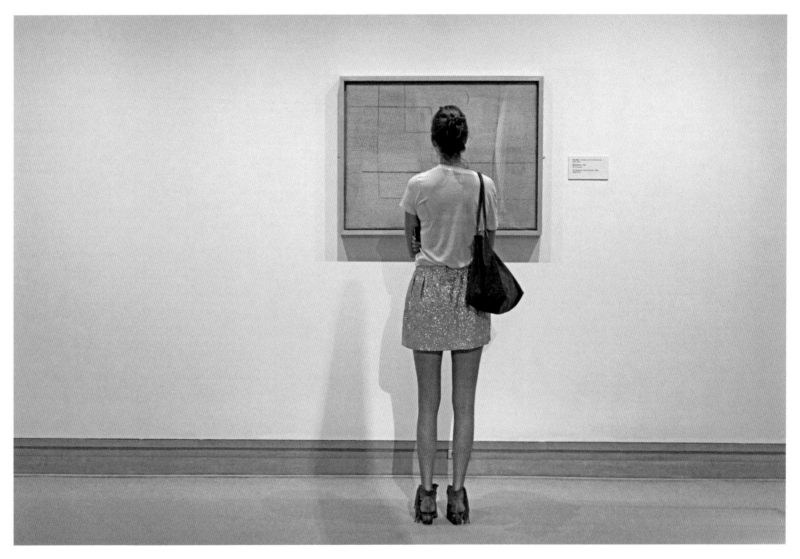

Paul Klee, *Clarification* (1932), Metropolitan Museum of Art, New York

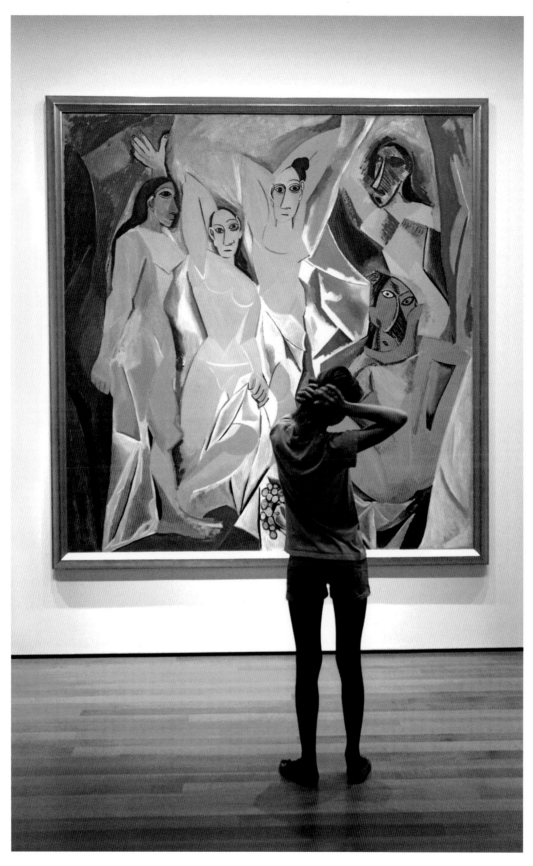

Pablo Picasso, *Les Demoiselles d'Avignon* (1907), Museum of Modern Art, New York

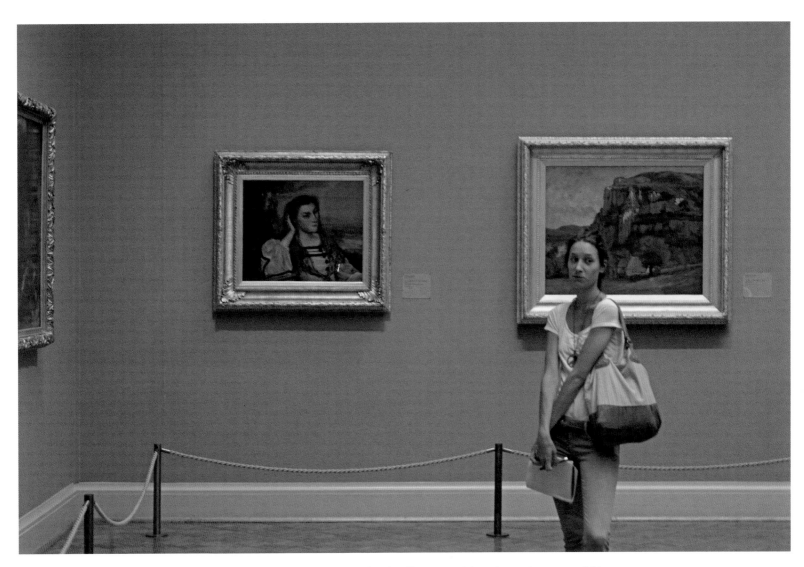

Gustave Courbet, *Rêverie (Portrait of Gabrielle Borreau)* (1862), Art Institute of Chicago

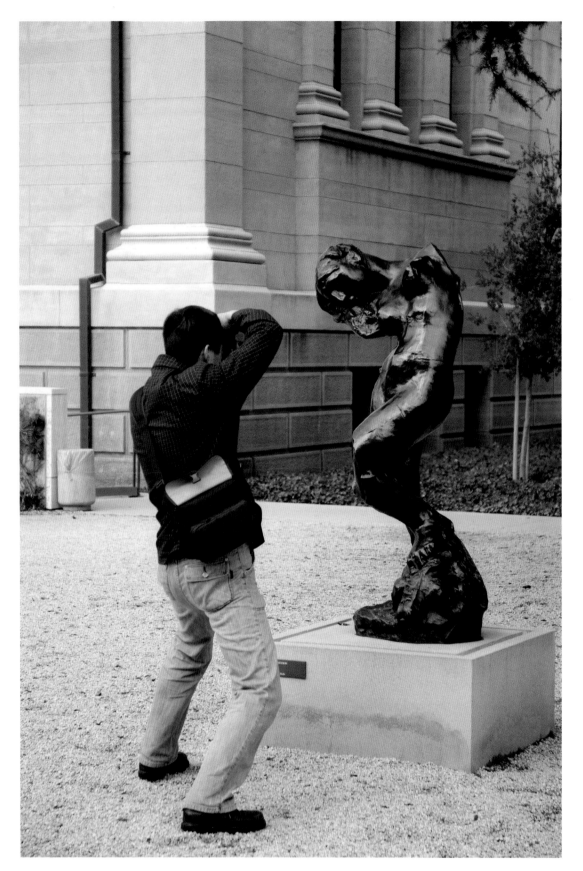

Auguste Rodin, *Meditation* (1896), Iris and B. Gerald Cantor Center for Visual Arts at Stanford University

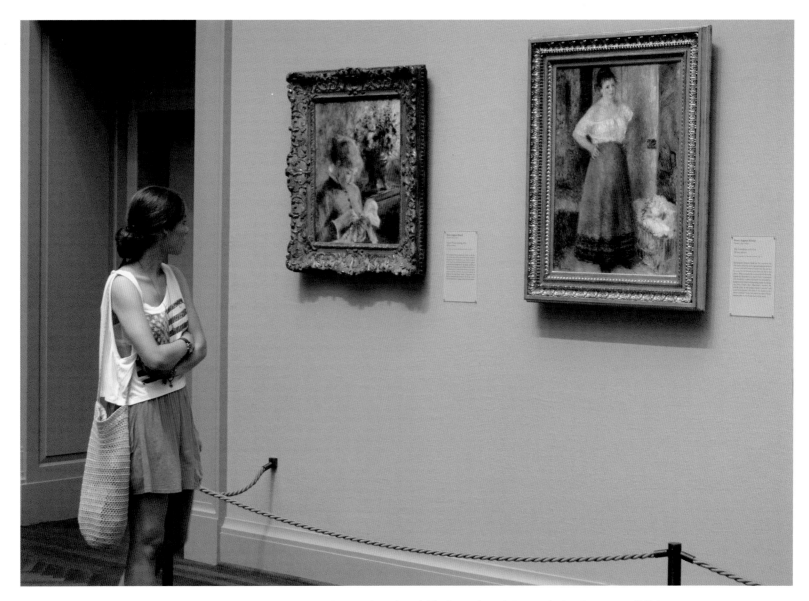

Pierre-Auguste Renoir, *Young Woman Sewing* (1879) and *The Laundress* (1877–79), Art Institute of Chicago

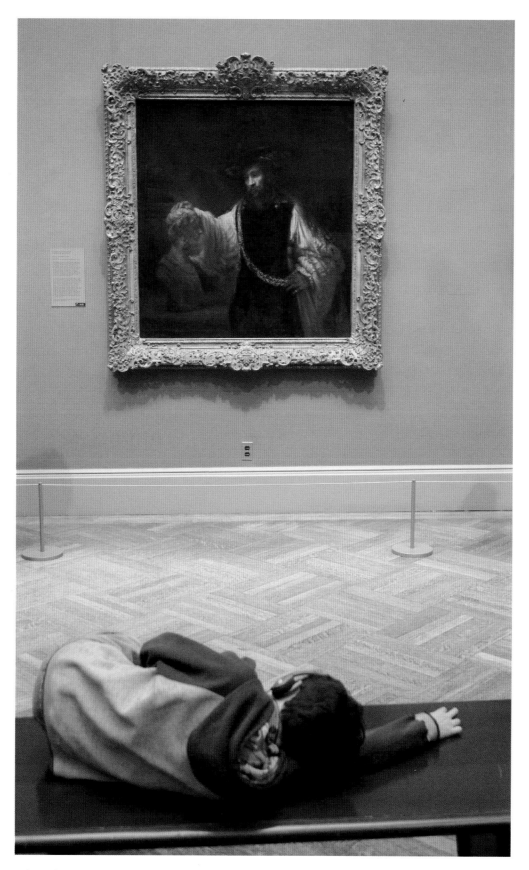

Rembrandt van Rijn, *Aristotle with a Bust of Homer* (1653), Metropolitan Museum of Art, New York

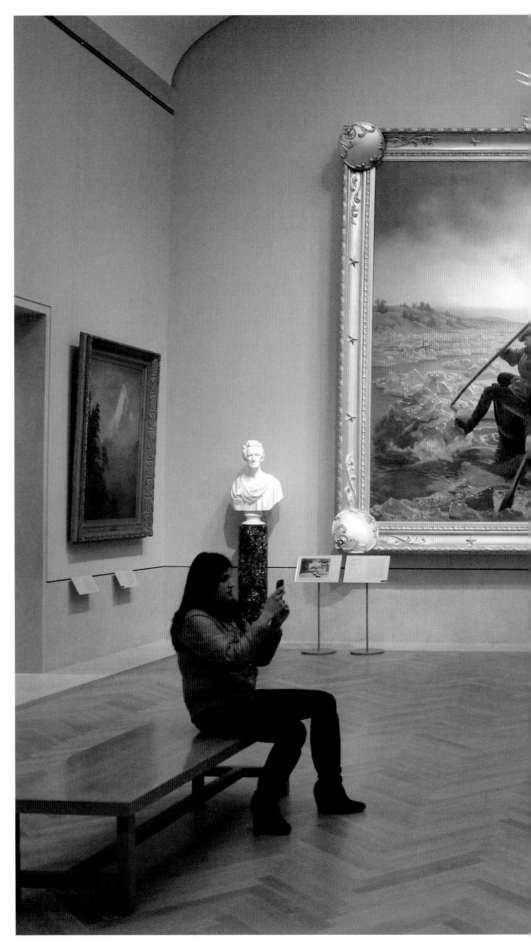

Emanuel Leutze, *Washington Crossing the Delaware* (1851),
Metropolitan Museum of Art, New York

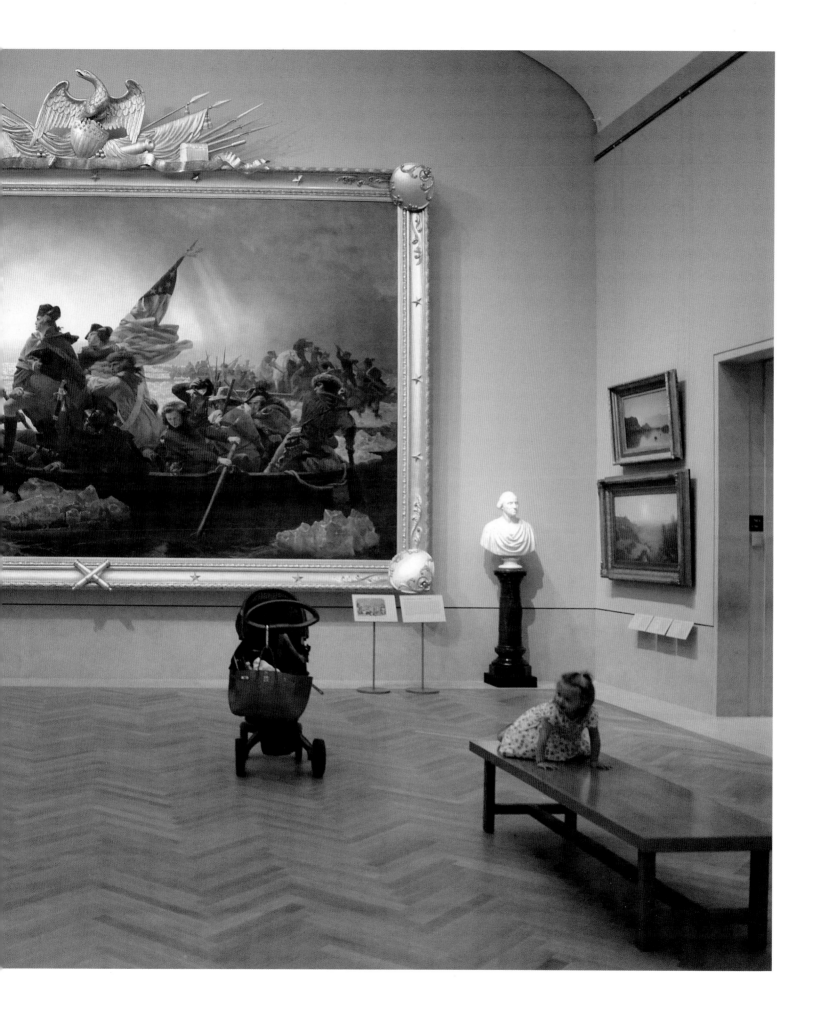

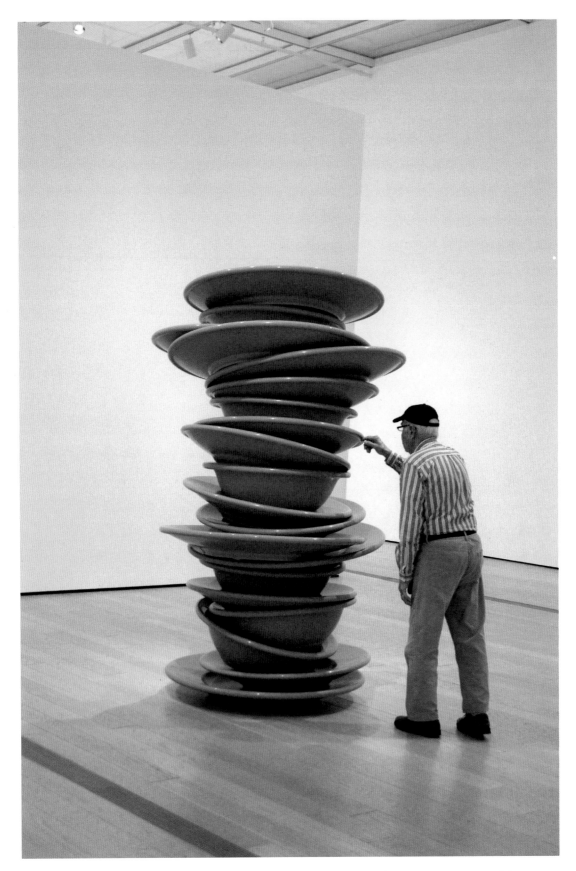

Robert Therrien, *No Title (Blue Plastic Plates)* (1999), Los Angeles County Museum of Art

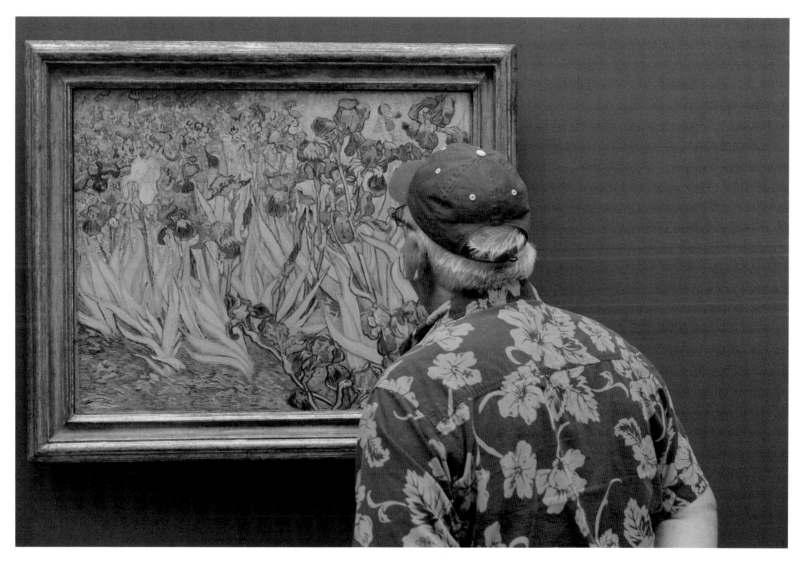

Vincent van Gogh, *Irises* (1889), J. Paul Getty Museum, Los Angeles

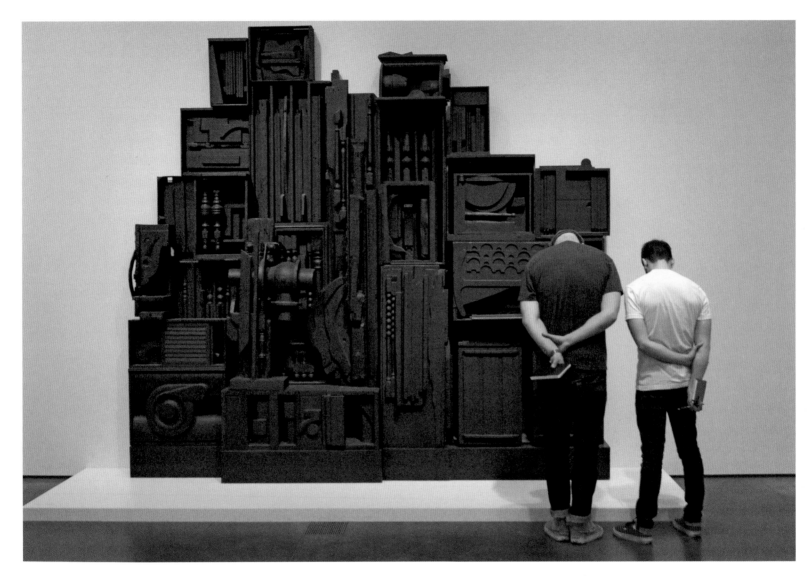

Louise Nevelson, *Sky Cathedral* (1959), Los Angeles County Museum of Art
(from the collection of the Museum of Contemporary Art, Los Angeles)

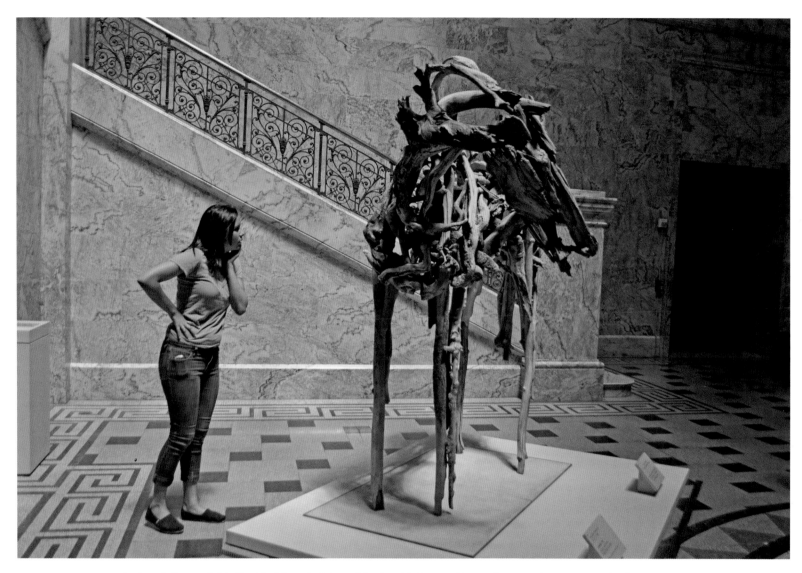

Deborah Butterfield, *Untitled* (1999), Iris and B. Gerald Cantor Center for Visual Arts at Stanford University

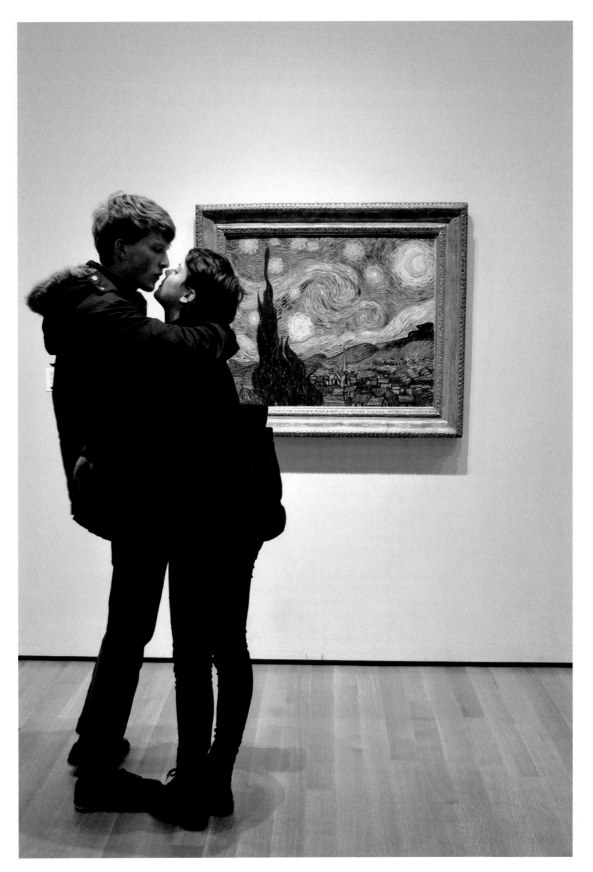

Vincent van Gogh, *The Starry Night* (1889), Museum of Modern Art, New York

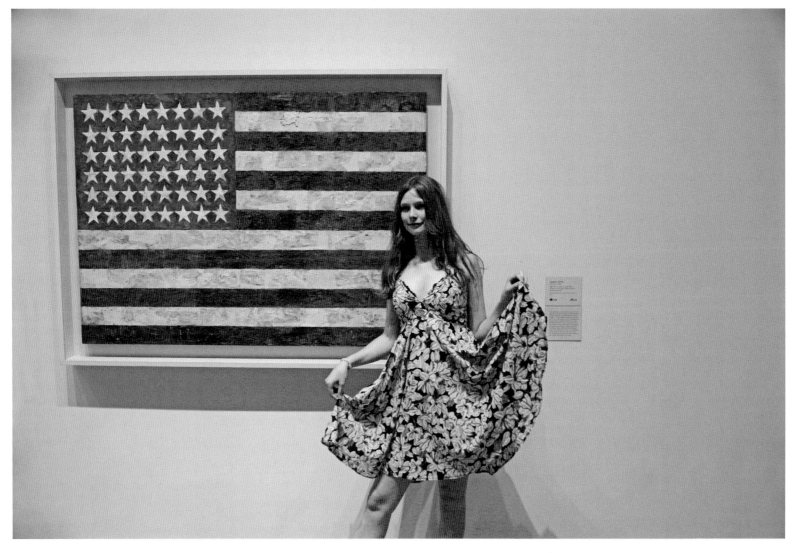

Jasper Johns, *Flag* (1954–55), Museum of Modern Art, New York

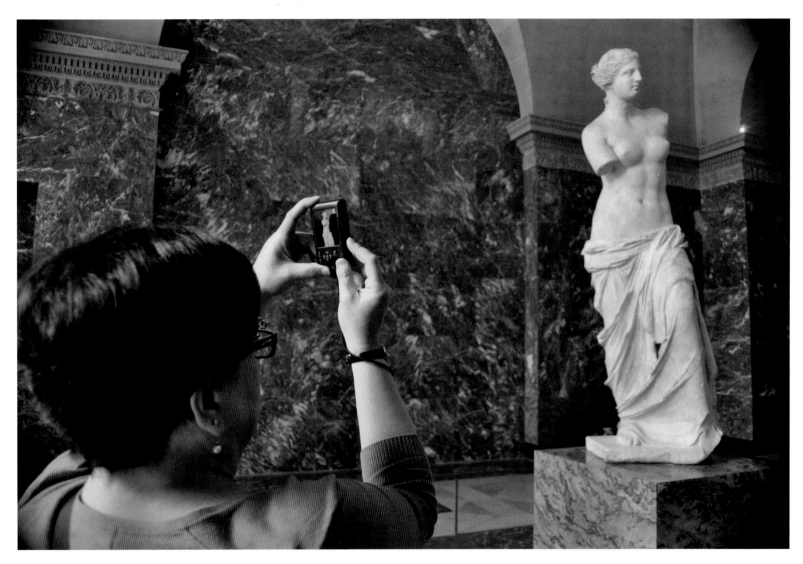

Alexandros of Antioch, *Venus de Milo* (c. 130 BCE), Musée du Louvre, Paris

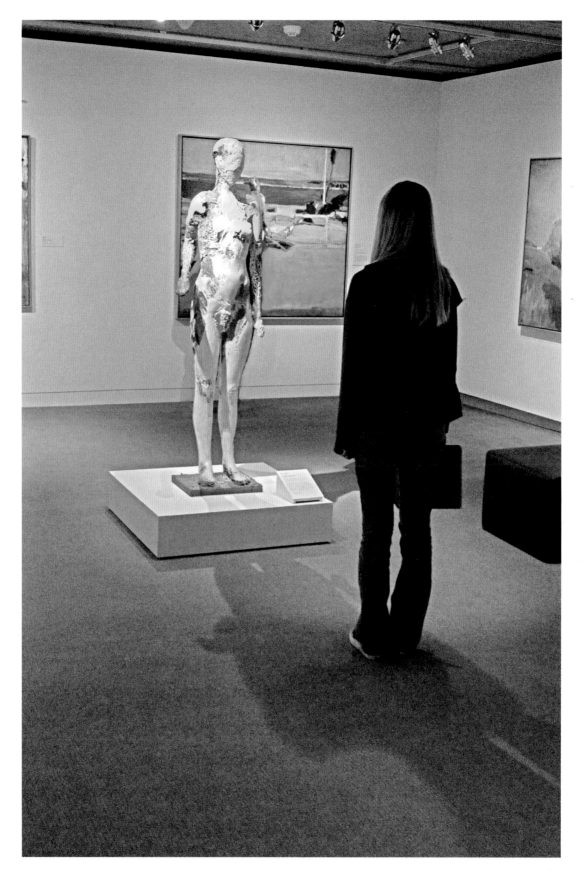

Manuel Neri, *Prietas Series VI* (1993), Oakland Museum of California

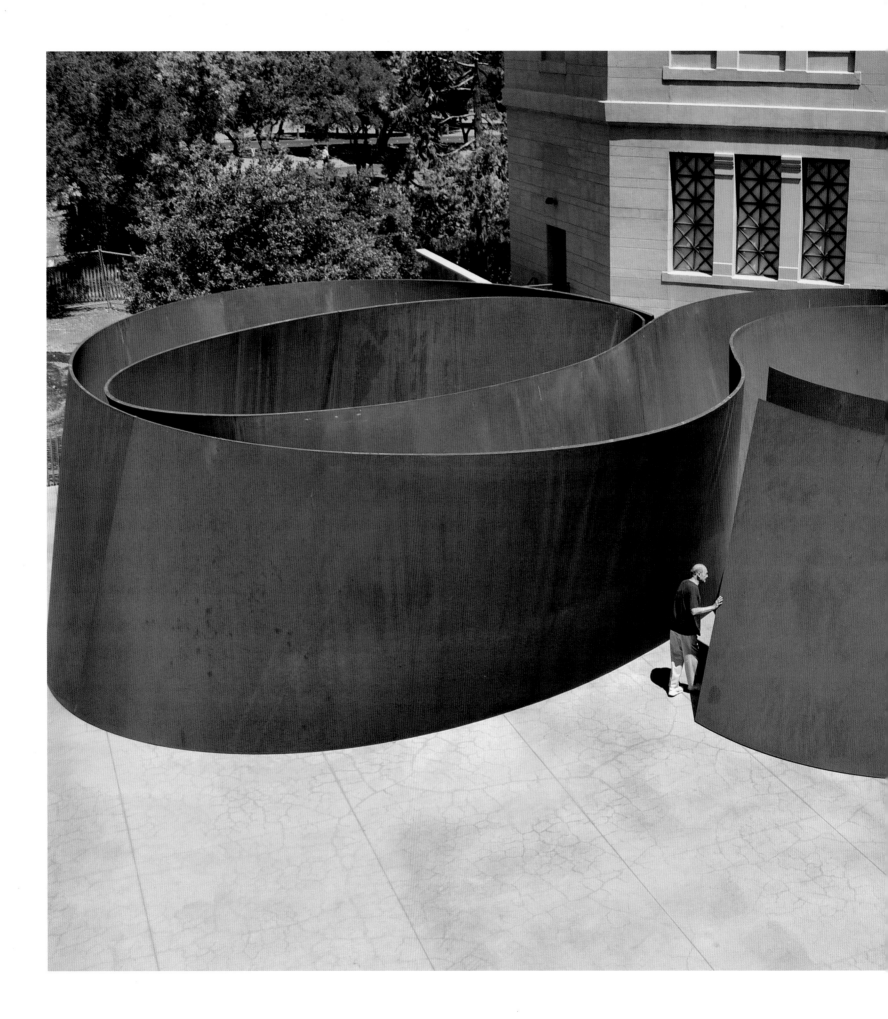

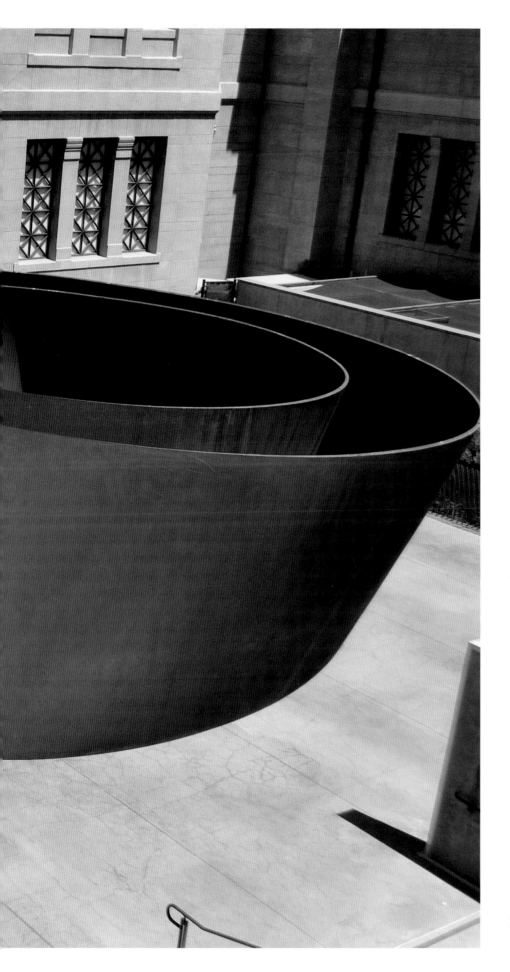

Richard Serra, *Sequence* (2006), Iris and B. Gerald Cantor
Center for Visual Arts at Stanford University

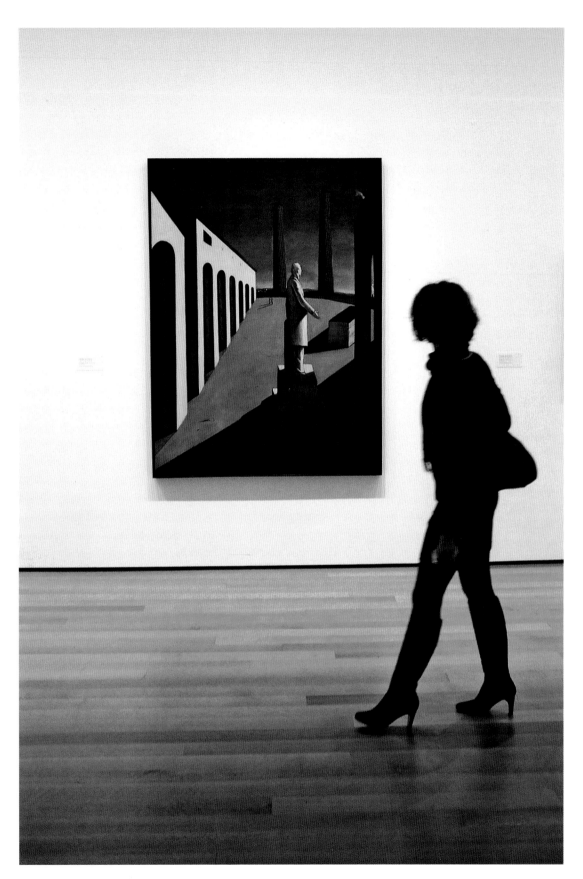

Giorgio de Chirico, *The Enigma of a Day* (1914), Museum of Modern Art, New York

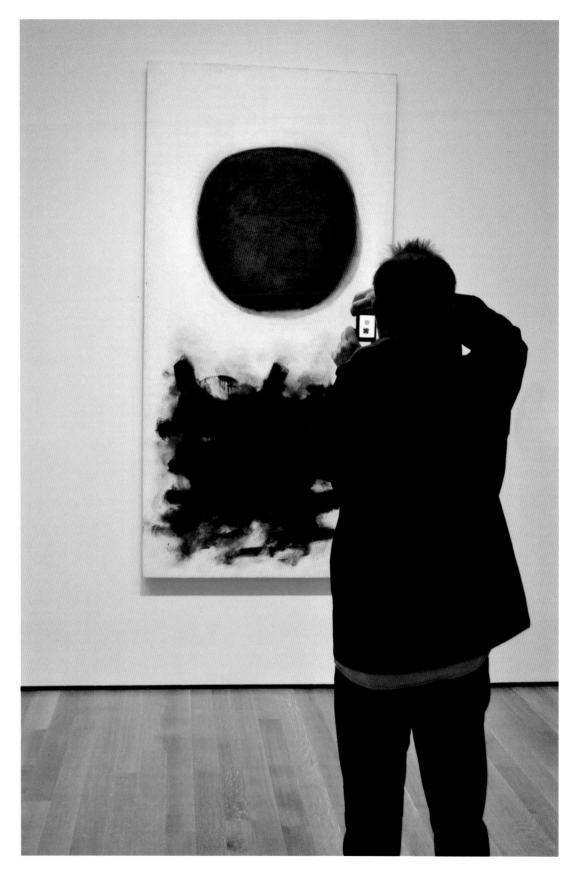

Adolph Gottlieb, *Blast, I* (1957), Museum of Modern Art, New York

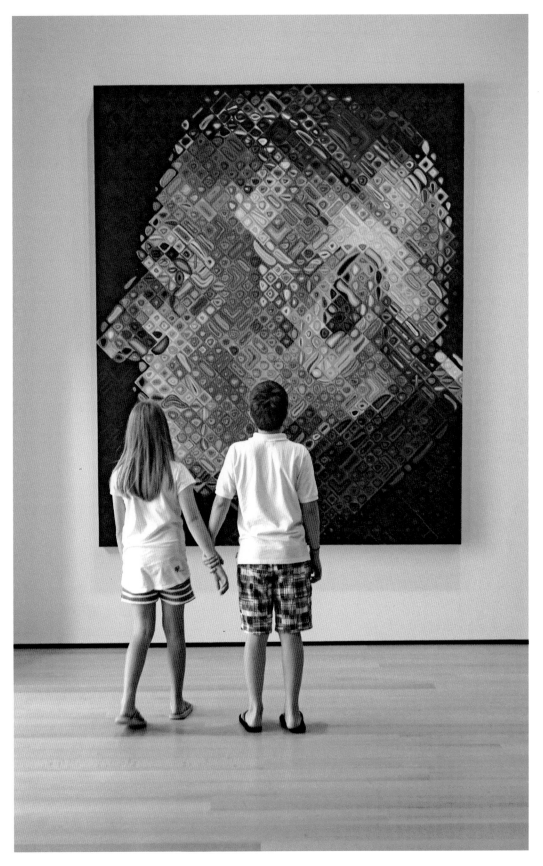

Chuck Close, *Paul IV* (2001), Museum of Fine Arts, Boston

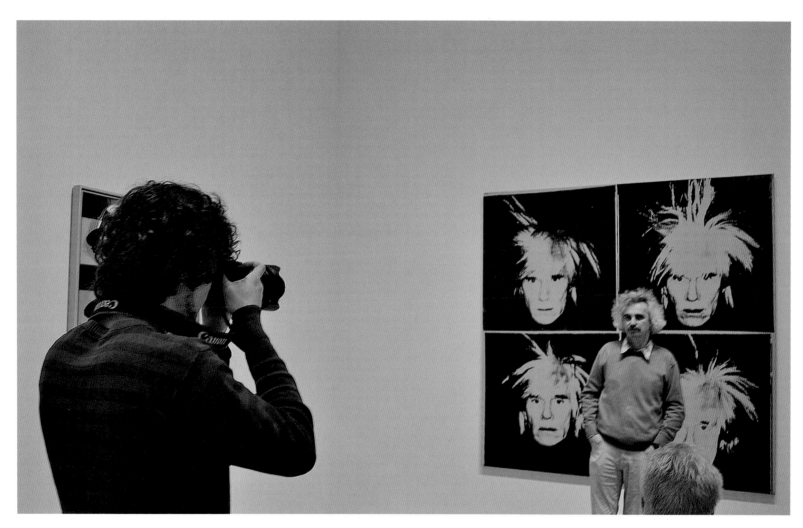

Andy Warhol, *Self-Portrait* (1986), San Francisco Museum of Modern Art

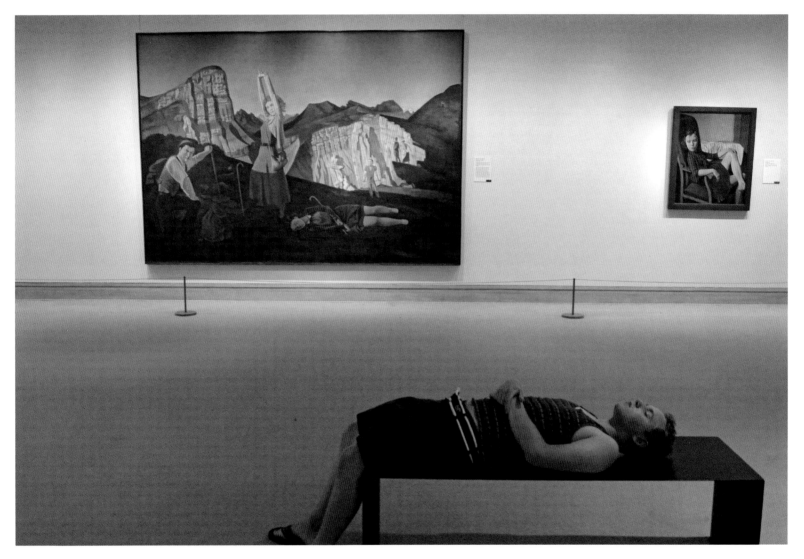

Balthus, *The Mountain* (1936–37) and *Thérèse* (1938), Metropolitan Museum of Art, New York

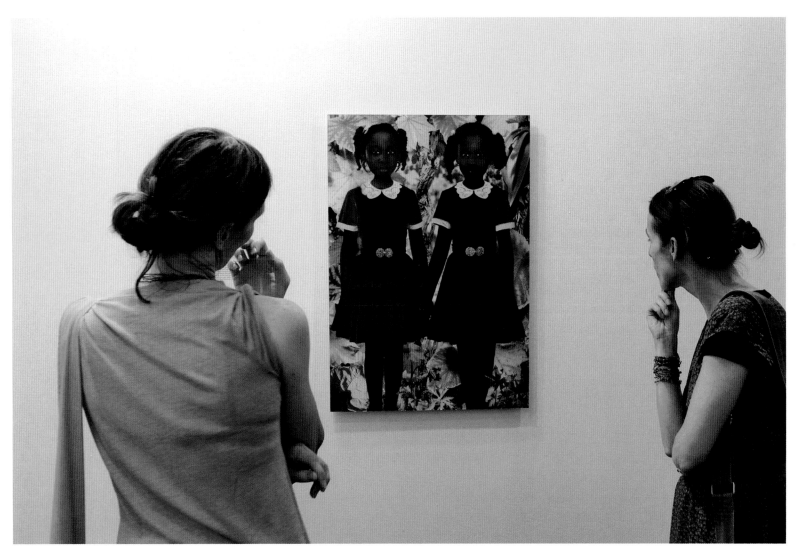

Ruud van Empel, *World #31* from the *World* series (2008), Center for Photography at Woodstock

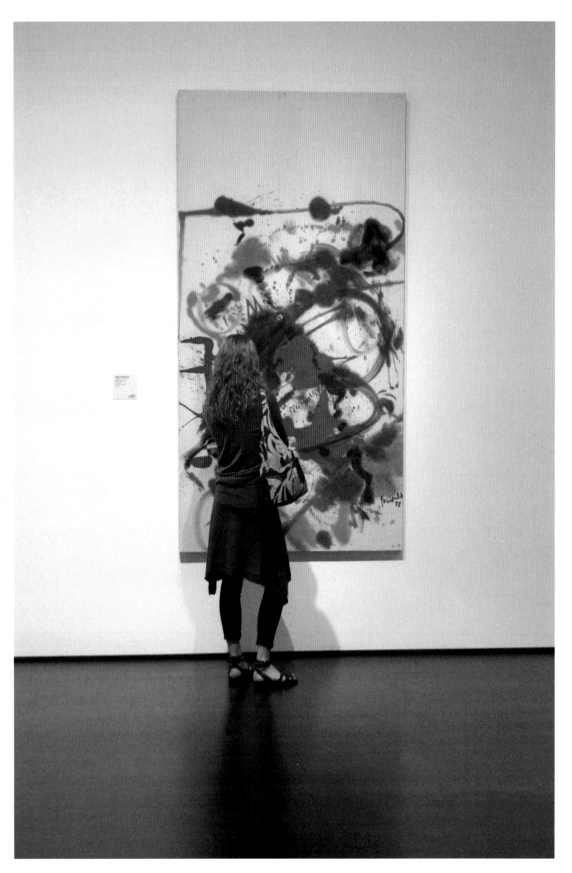

Helen Frankenthaler, *Winter Hunt* (1958), Los Angeles County Museum of Art

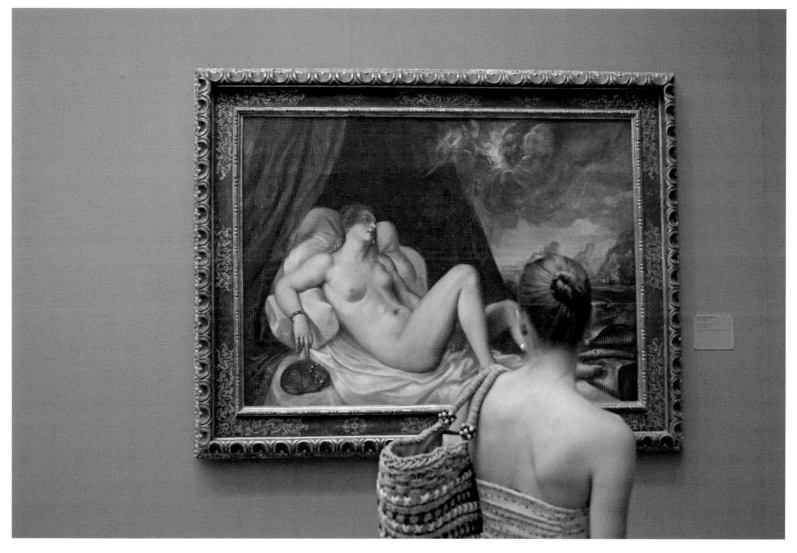

Titian, *Danaë* (c. 1555), Art Institute of Chicago

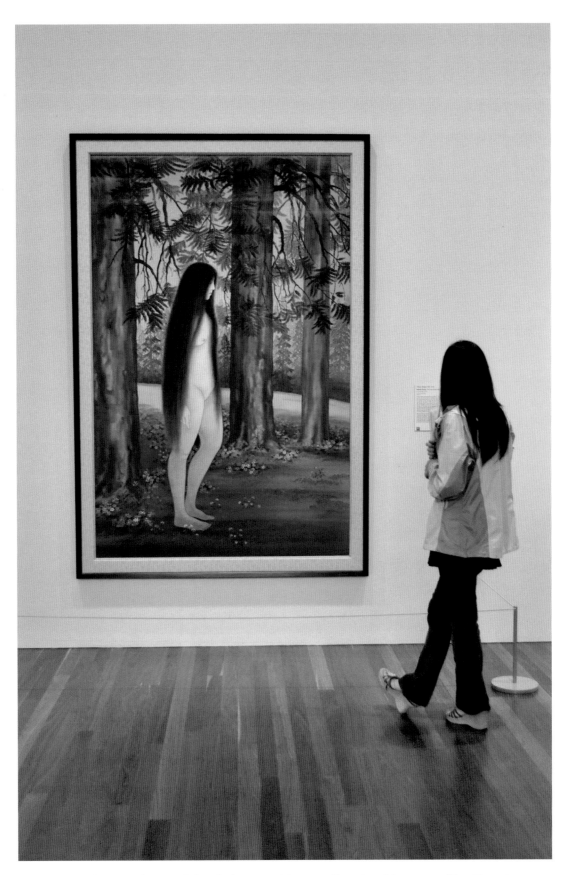

Chiura Obata, *Mother Earth* (1912), de Young Museum, Fine Arts Museums of San Francisco

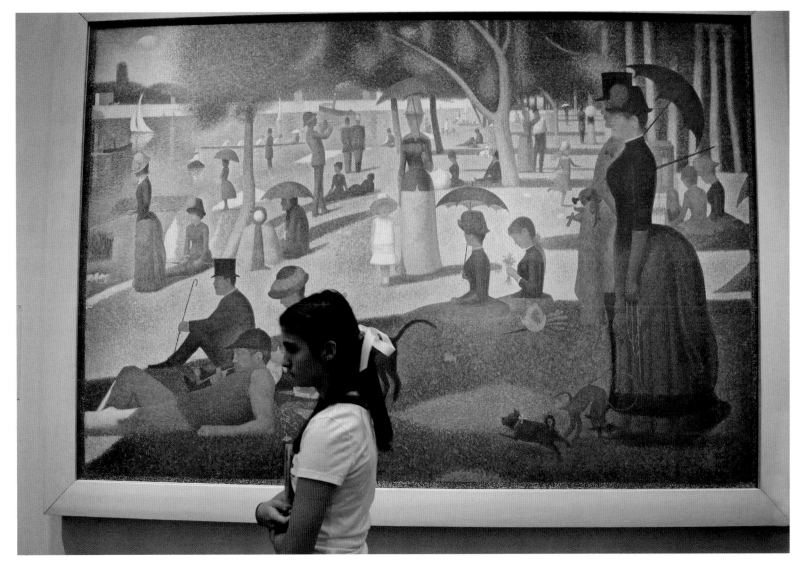

Georges Seurat, *A Sunday Afternoon on the Island of La Grande Jatte* (1884–86), Art Institute of Chicago

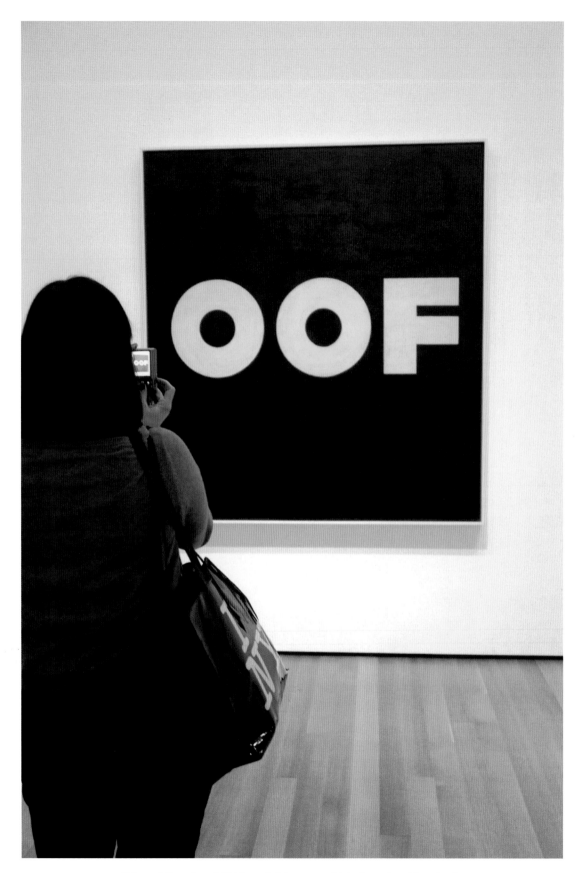

Edward Ruscha, *OOF* (1962), Museum of Modern Art, New York

Joel Shapiro, *Untitled* (1989), San Francisco Museum of Modern Art

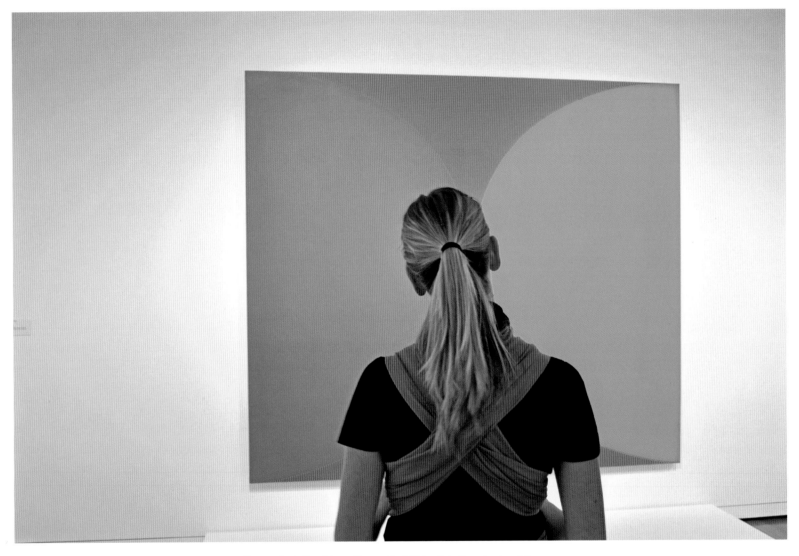

Ellsworth Kelly, *Blue, Green, Red II* (1965), Seattle Art Museum

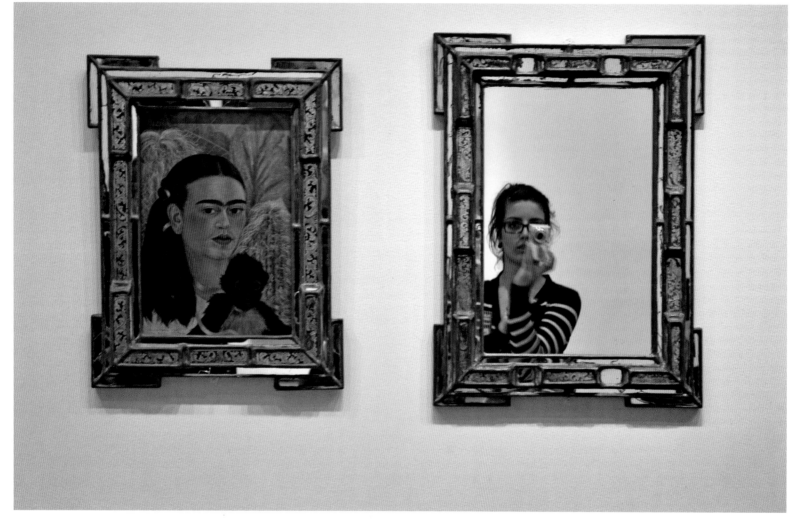

Frida Kahlo, *Fulang-Chang and I* (1937), Museum of Modern Art, New York

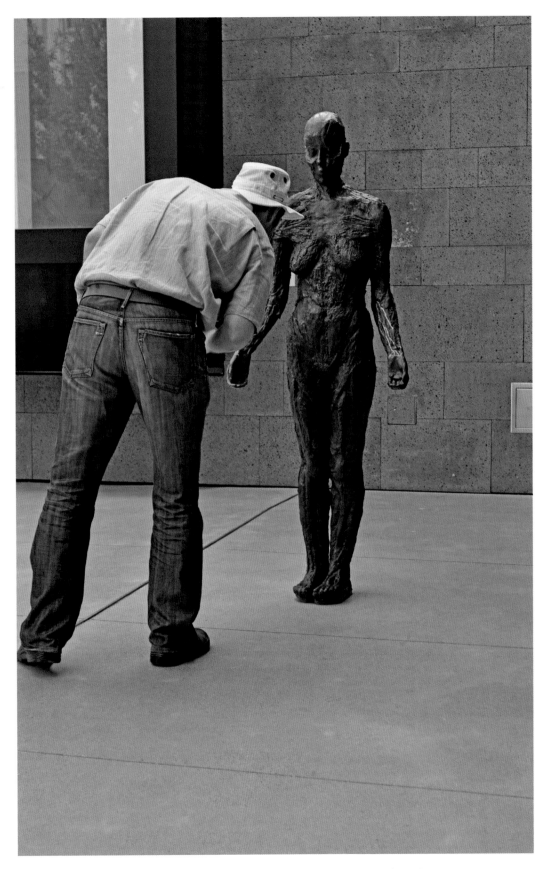

Kiki Smith, *Virgin Mary* (1993), San Francisco Museum of Modern Art

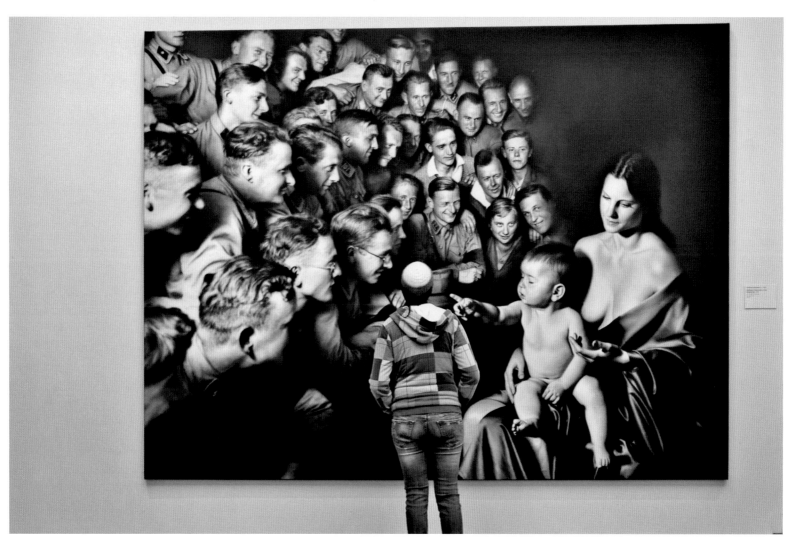

Gottfried Helnwein, *Epiphany II (Adoration of the Shepherds)* (1998), de Young Museum, Fine Arts Museums of San Francisco

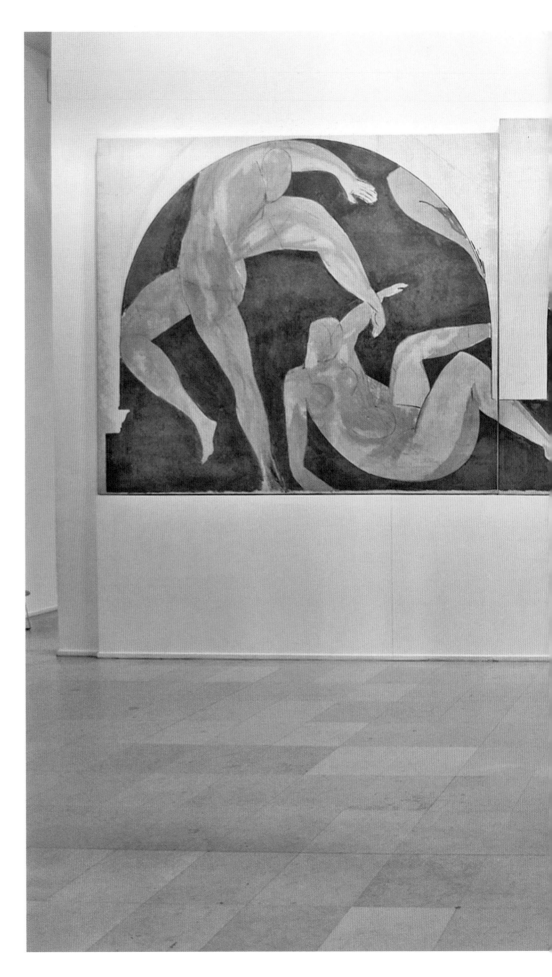

Henri Matisse, *The Unfinished Dance* (1931),
Musée d'Art Moderne de la Ville de Paris

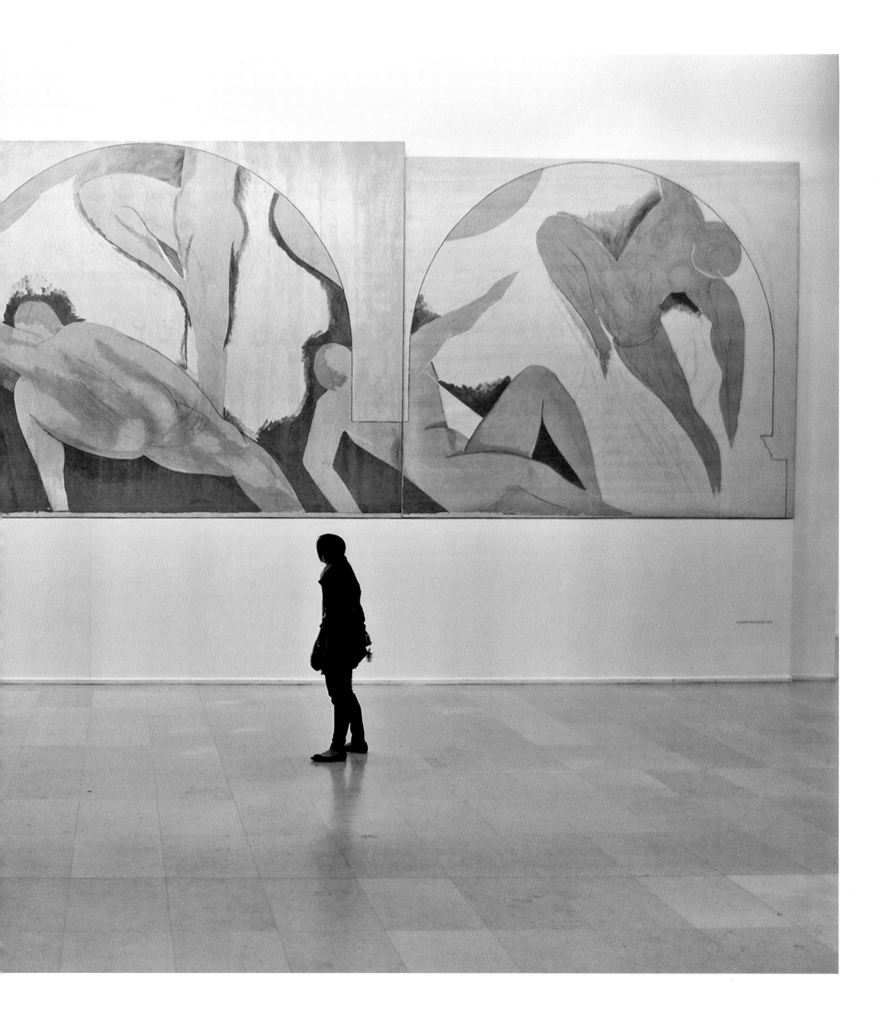

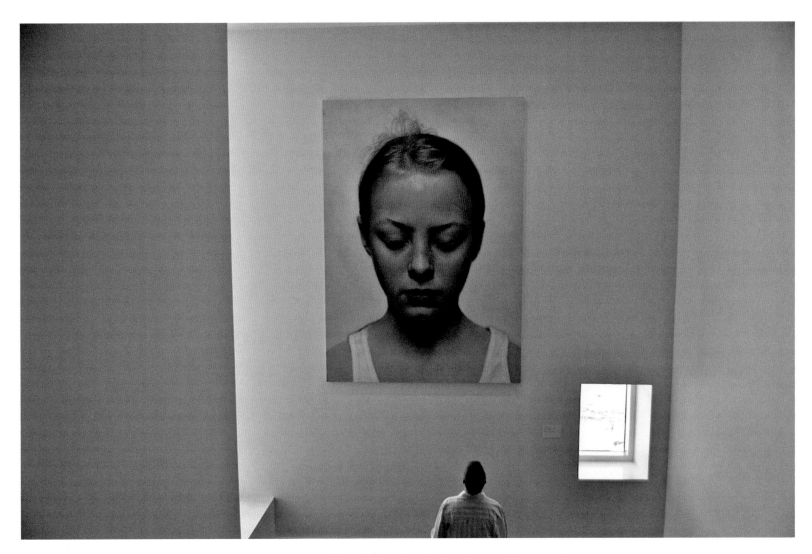

Gottfried Helnwein, *Head of a Child 10* (2004), Crocker Art Museum, Sacramento

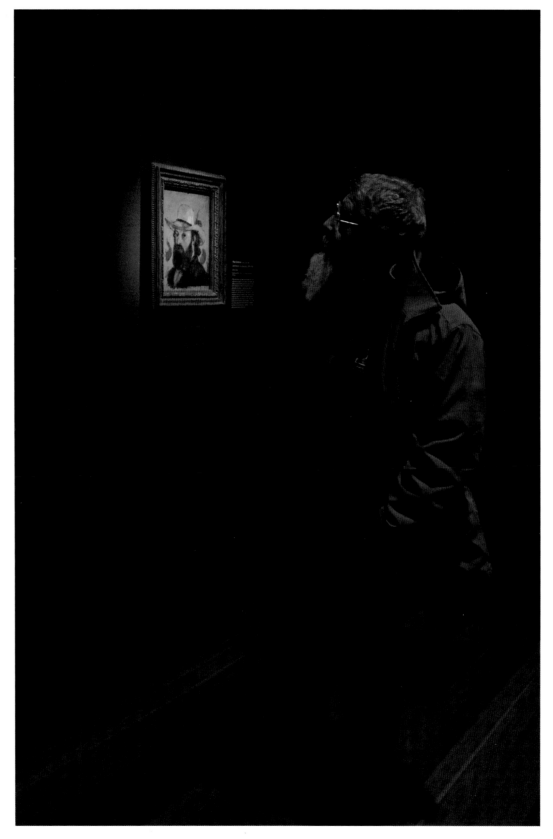

Paul Cézanne, *Self-Portrait in a Straw Hat* (1875–76), de Young Museum,
Fine Arts Museums of San Francisco (from the collection of the Museum of Modern Art, New York)

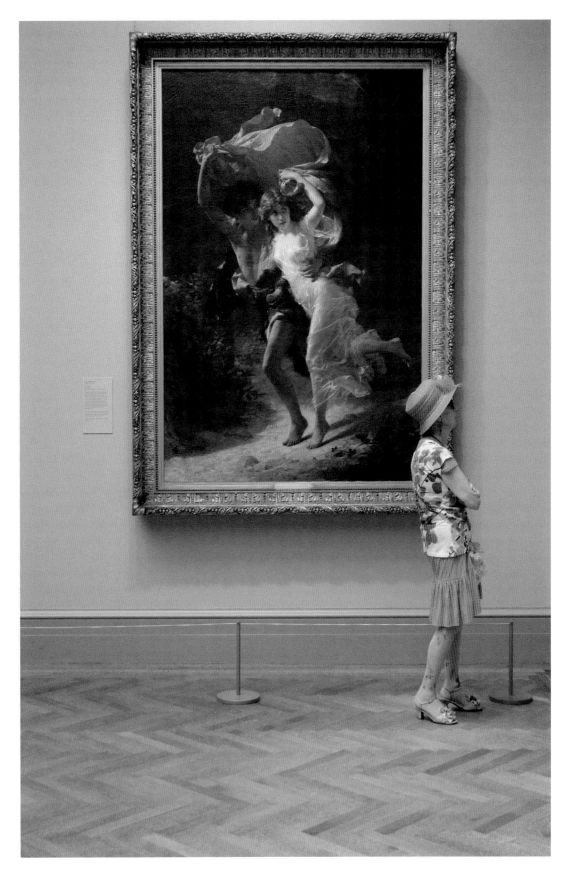

Pierre-Auguste Cot, *The Storm* (1880), Metropolitan Museum of Art, New York

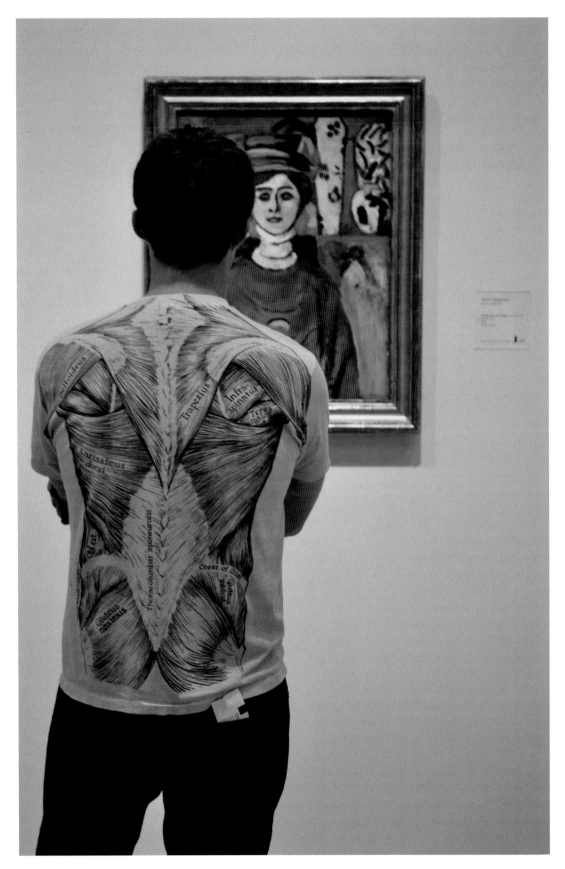

Henri Matisse, *The Girl with Green Eyes* (1908), San Francisco Museum of Modern Art

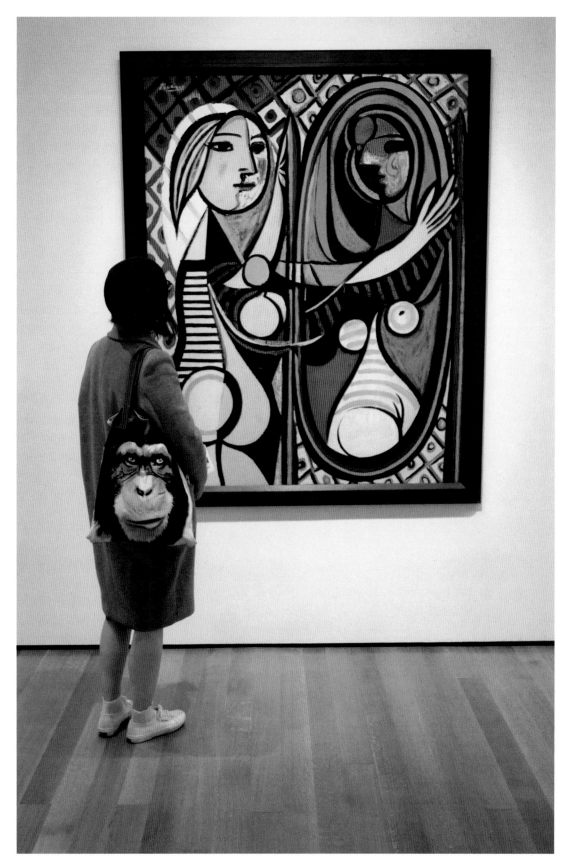

Pablo Picasso, *Girl Before a Mirror* (1932), Museum of Modern Art, New York

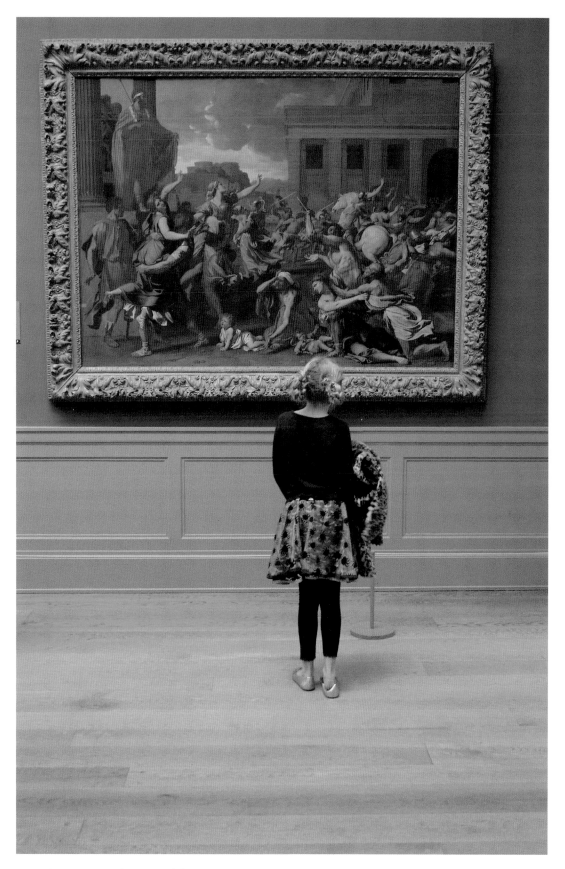

Nicolas Poussin, *The Rape of the Sabine Women* (1633–34), Metropolitan Museum of Art, New York

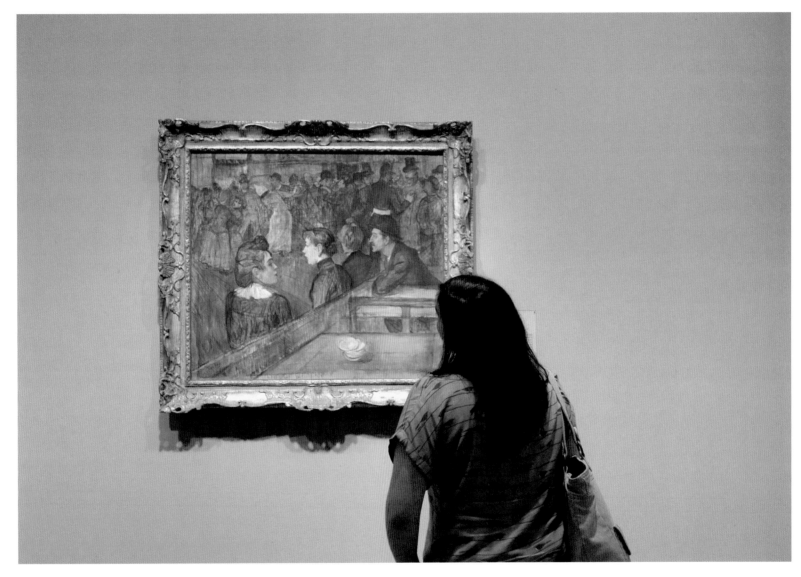

Henri de Toulouse-Lautrec, *Moulin de la Galette* (1889), Art Institute of Chicago

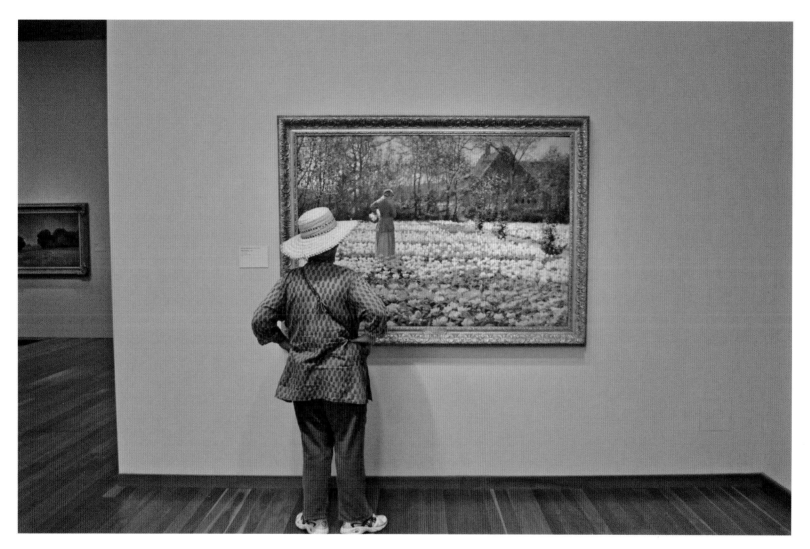

George Hitchcock, *Tulip Culture* (1889), de Young Museum, Fine Arts Museums of San Francisco

Edward Hopper, *Nighthawks* (1942),
Art Institute of Chicago

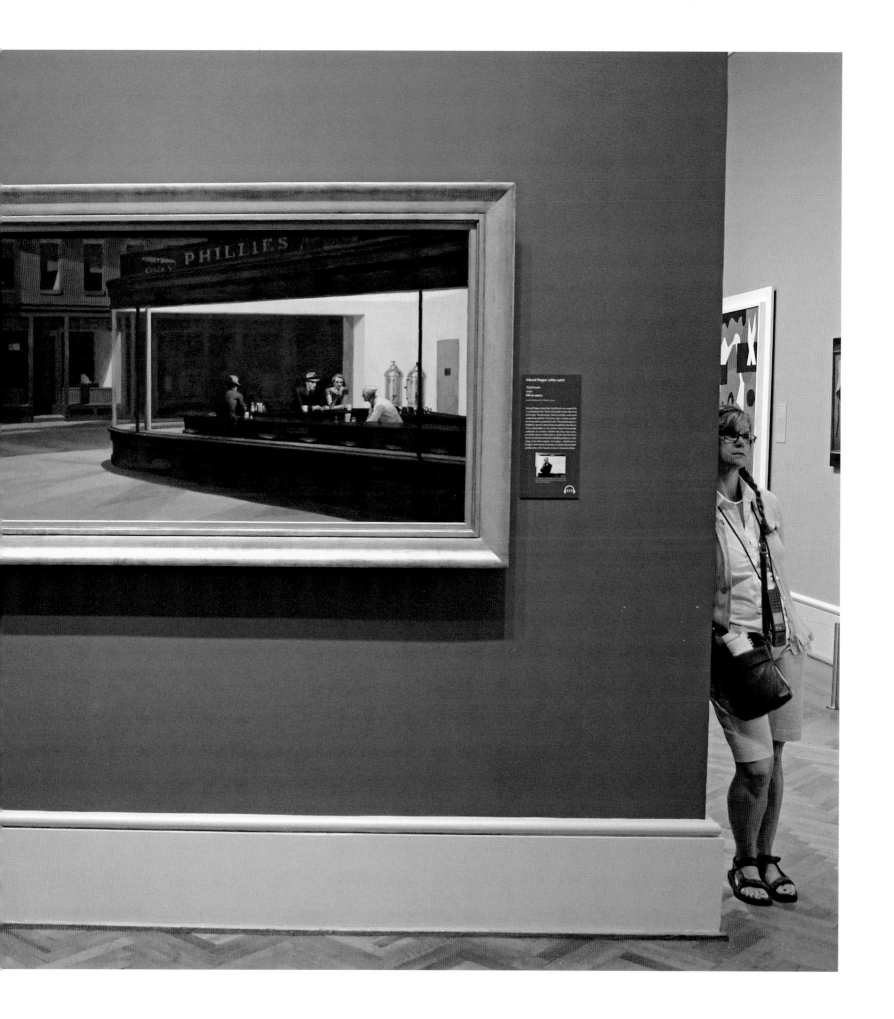

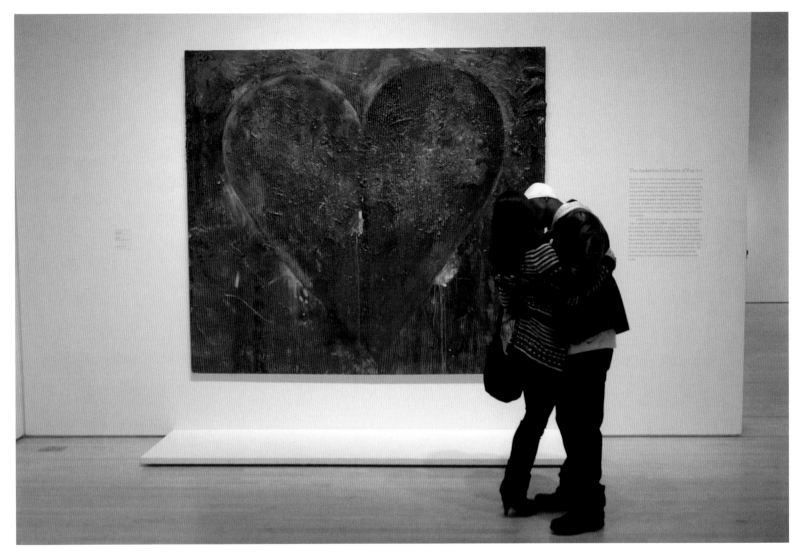

Jim Dine, *Blue Clamp* (1981), San Francisco Museum of Modern Art

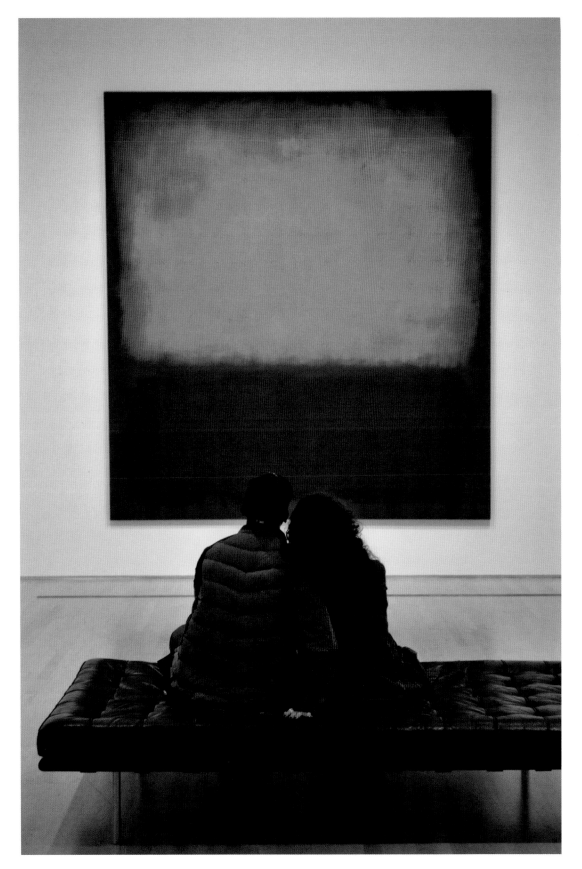

Mark Rothko, *No. 14, 1960* (1960), San Francisco Museum of Modern Art

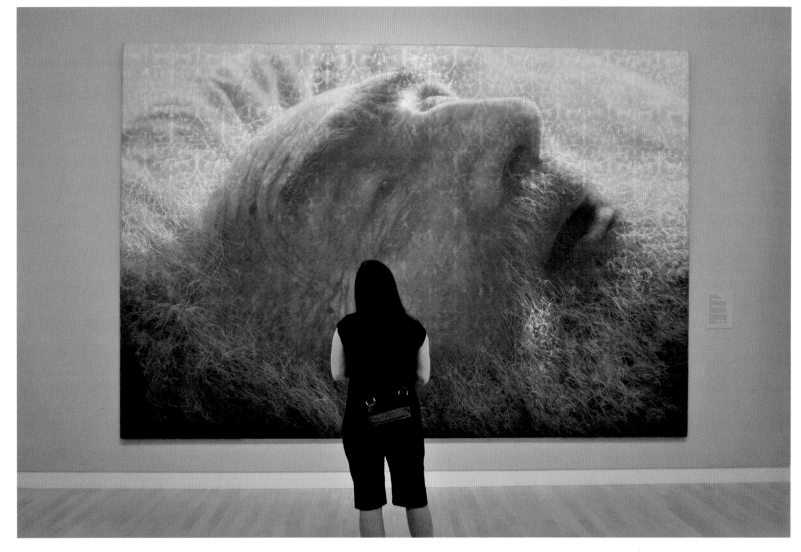

Stephen J. Kaltenbach, *Portrait of My Father* (1972–79), Crocker Art Museum, Sacramento

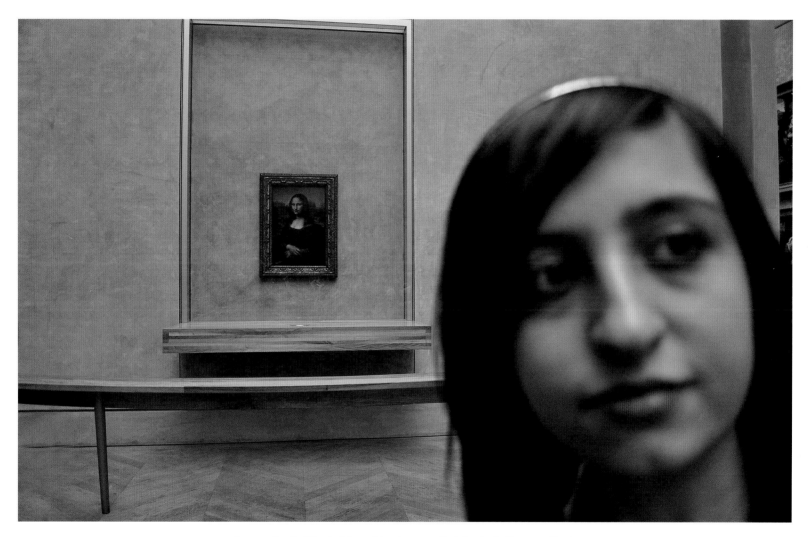

Leonardo da Vinci, *Mona Lisa* (1503–06), Musée du Louvre, Paris

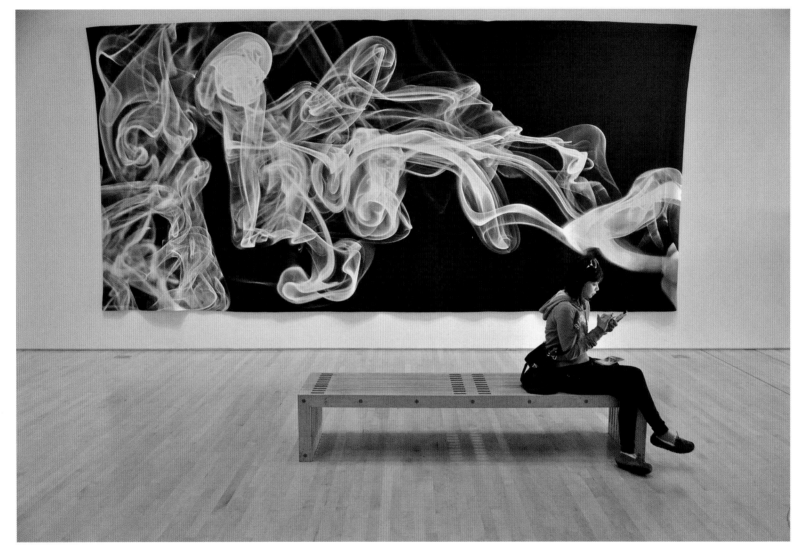

Pae White, *Smoke Knows* (2009), San Francisco Museum of Modern Art

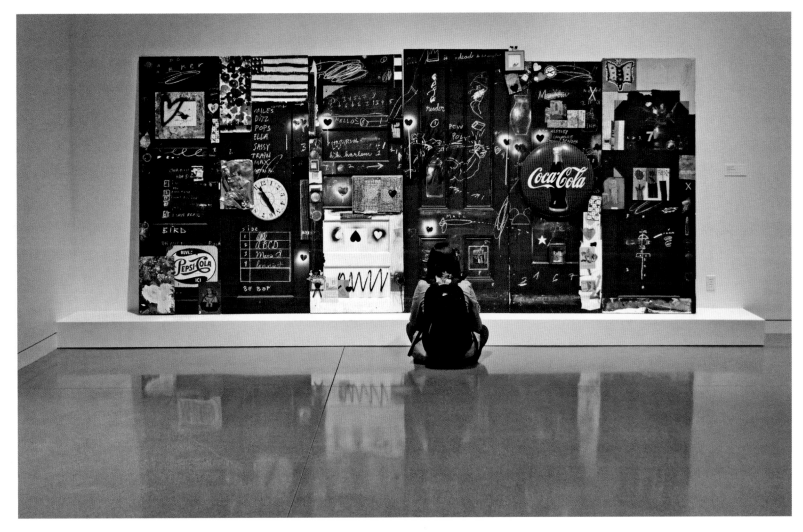

Raymond Saunders, *The Gift of Presence* (1993–94), Oakland Museum of California

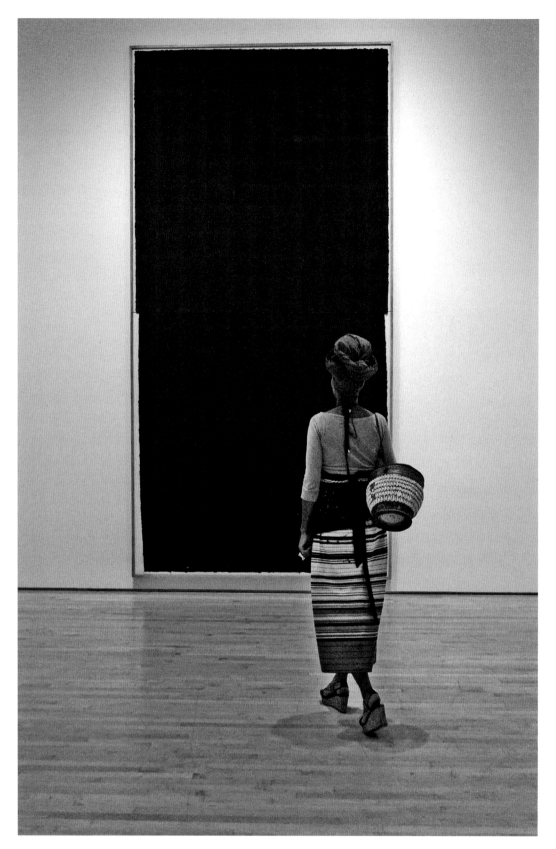

Richard Serra, *Deadweight V (Memphis)* (1991), San Francisco Museum of Modern Art
(from the collection of the Museum of Modern Art, New York)

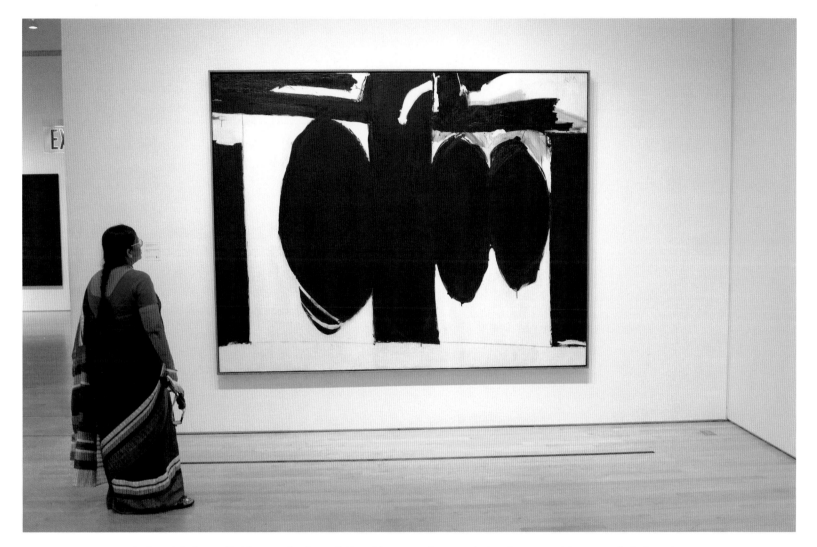

Robert Motherwell, *Elegy to the Spanish Republic No. 57* (1957–60), San Francisco Museum of Modern Art

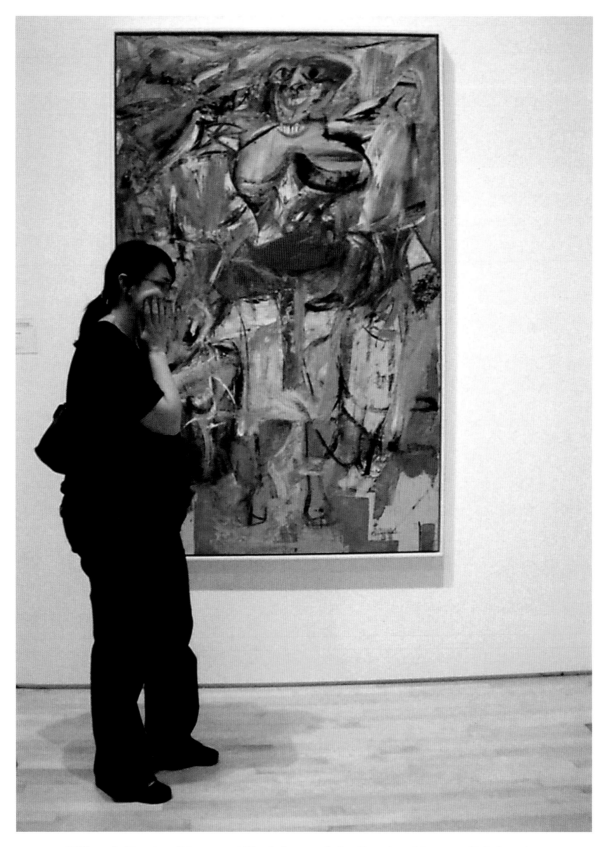

Willem de Kooning, *Woman and Bicycle* (1952–53), San Francisco Museum of Modern Art
(from the collection of the Whitney Museum of American Art, New York)

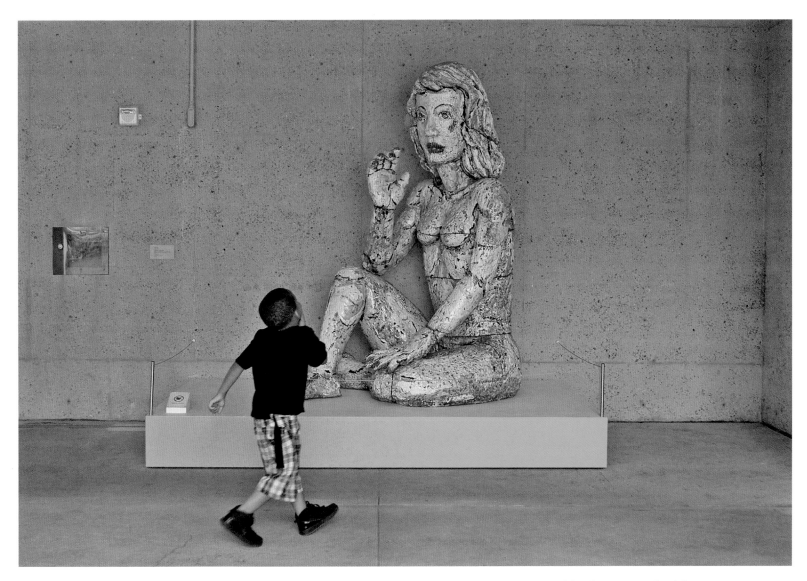

Viola Frey, *Woman with Elbow on Raised Knee* from the *American Nude* series (1994), Oakland Museum of California

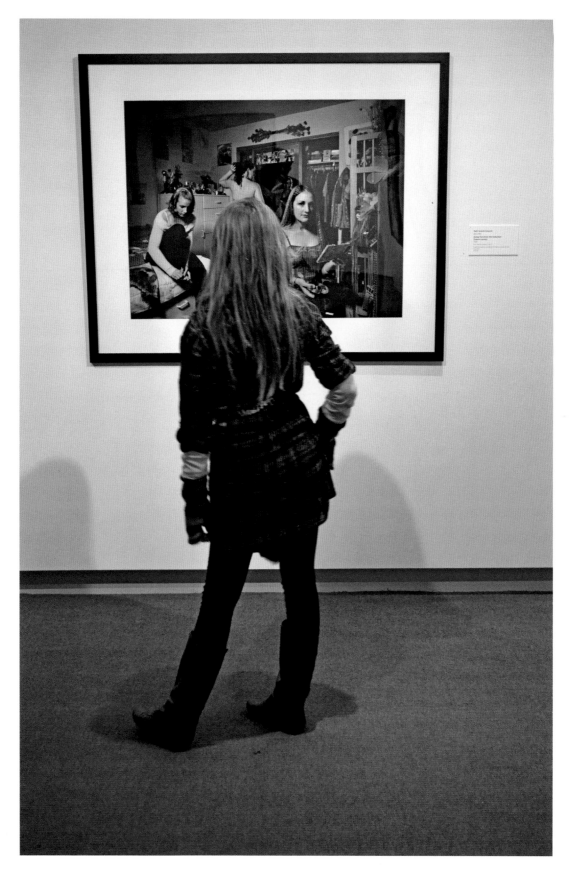

Beth Yarnelle Edwards, *Nicki (Going Out)* from the *Suburban Dreams* series (2000), Oakland Museum of California

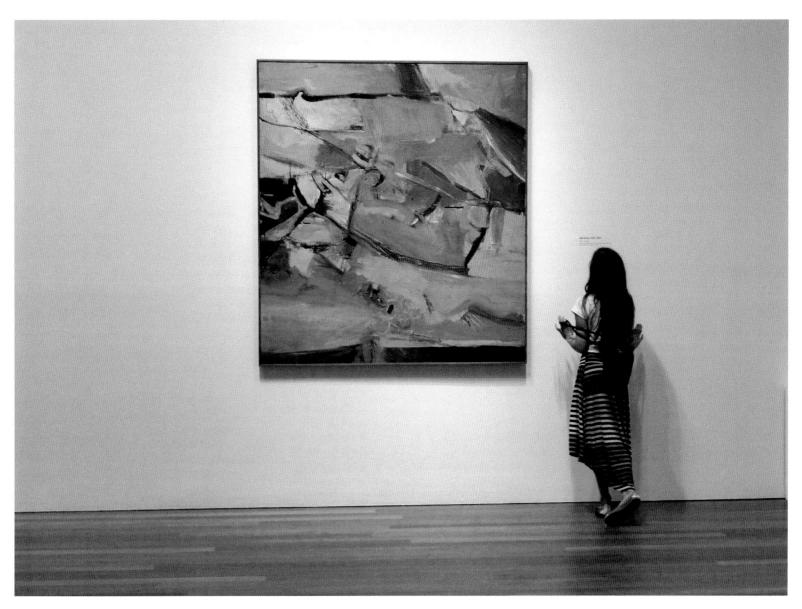

Richard Diebenkorn, *Berkeley #38* (1955), de Young Museum, Fine Arts Museums of San Francisco
(from the collection of Carnegie Museum of Art, Pittsburgh)

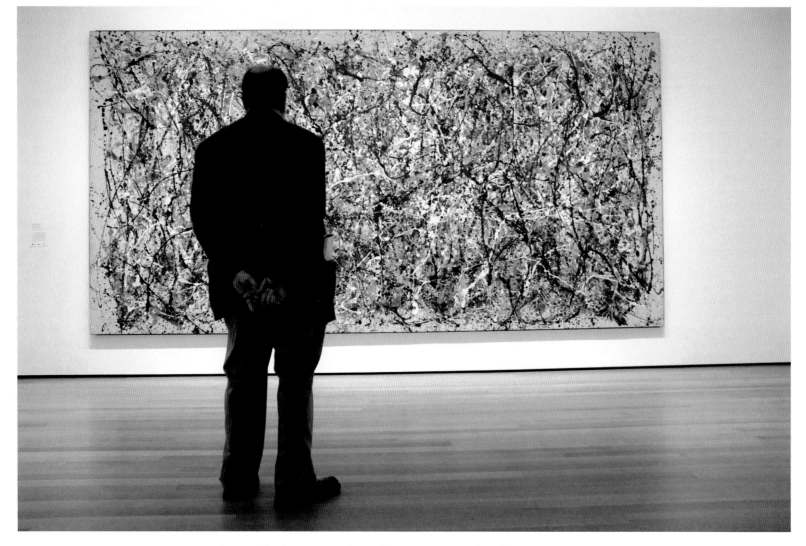

Jackson Pollock, *One: Number 31* (1950), Museum of Modern Art, New York

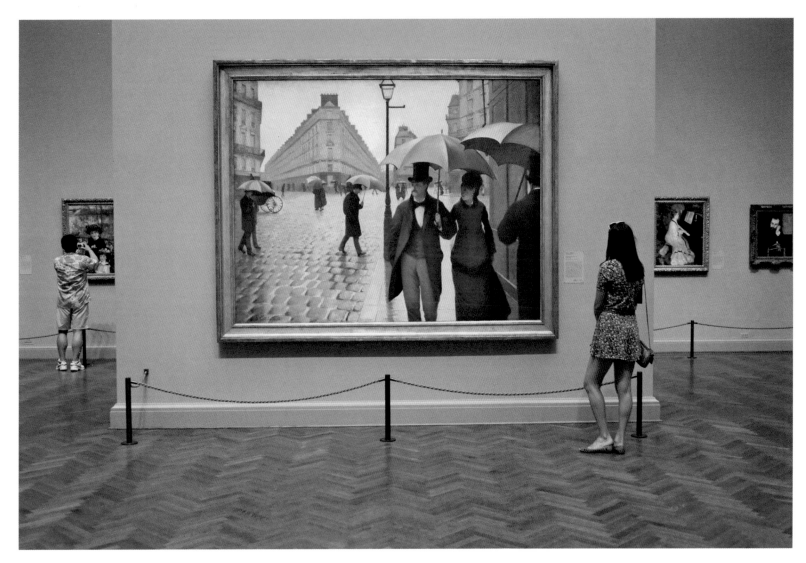

Gustave Caillebotte, *Paris Street; Rainy Day* (1877), Art Institute of Chicago

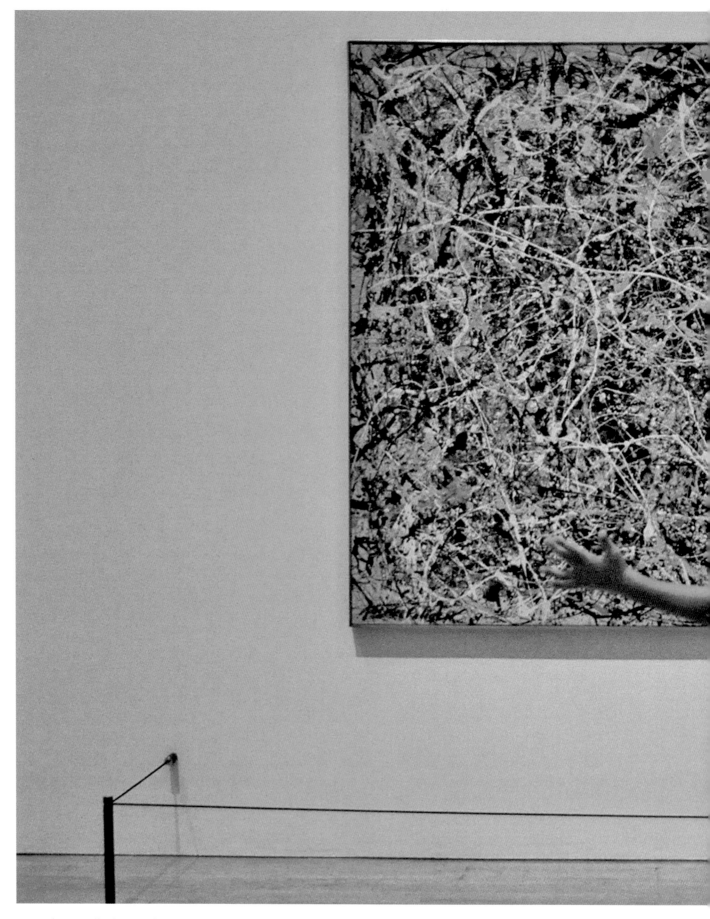

Jackson Pollock, *Number 1, 1949* (1949), Museum of Contemporary Art, Los Angeles

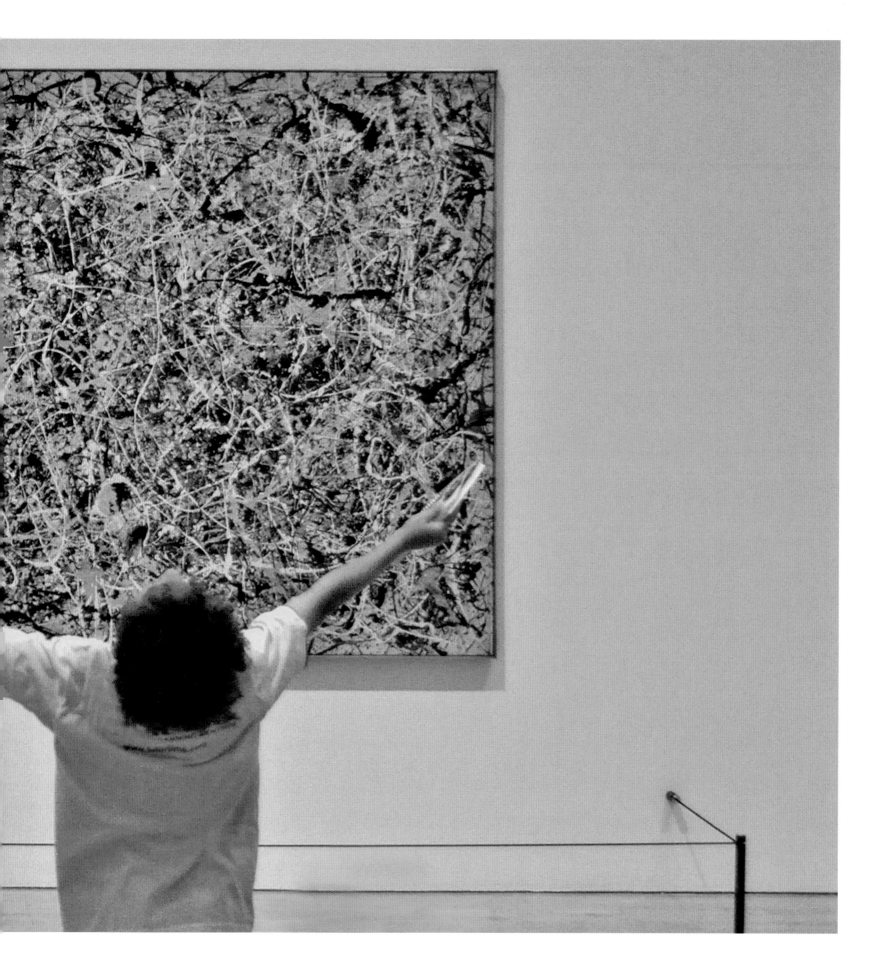

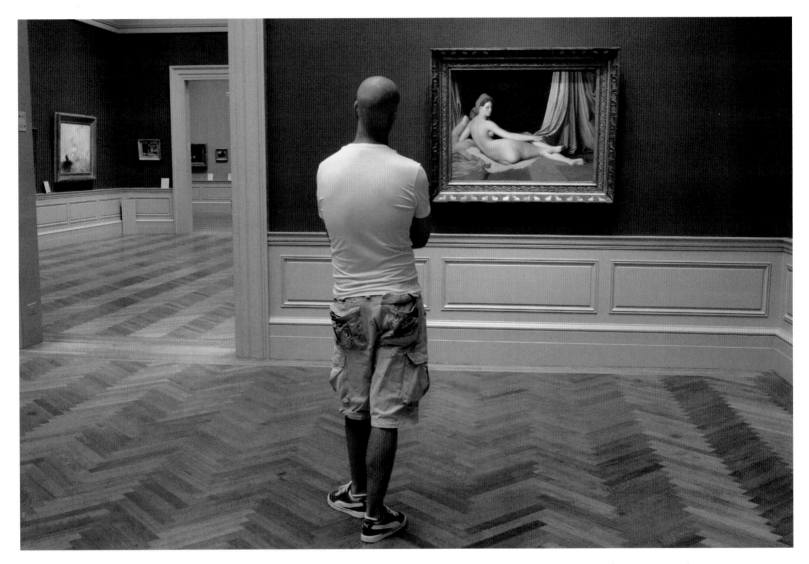

Jean-Auguste-Dominique Ingres, *Odalisque in Grisaille* (c. 1824–34), Metropolitan Museum of Art, New York

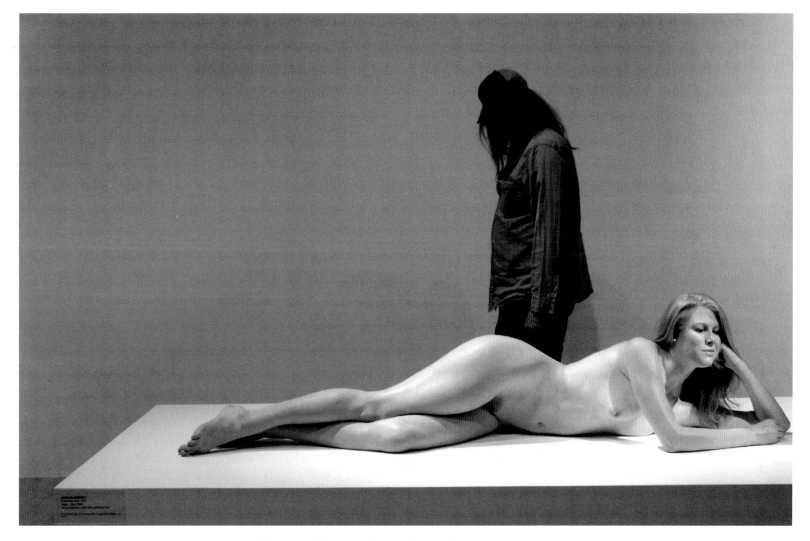

John De Andrea, *Joan* (c. 1990), Palm Springs Art Museum

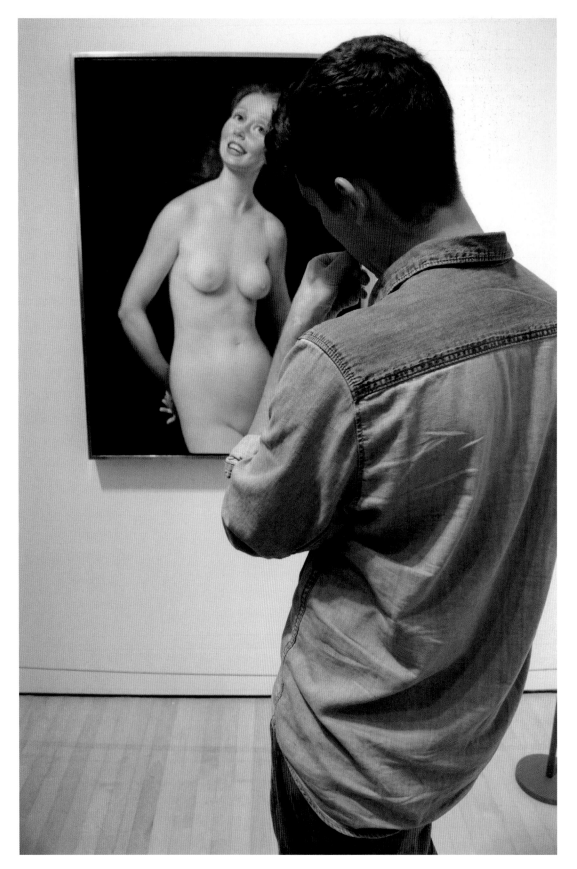

John Currin, *Laughing Nude* (1998), San Francisco Museum of Modern Art

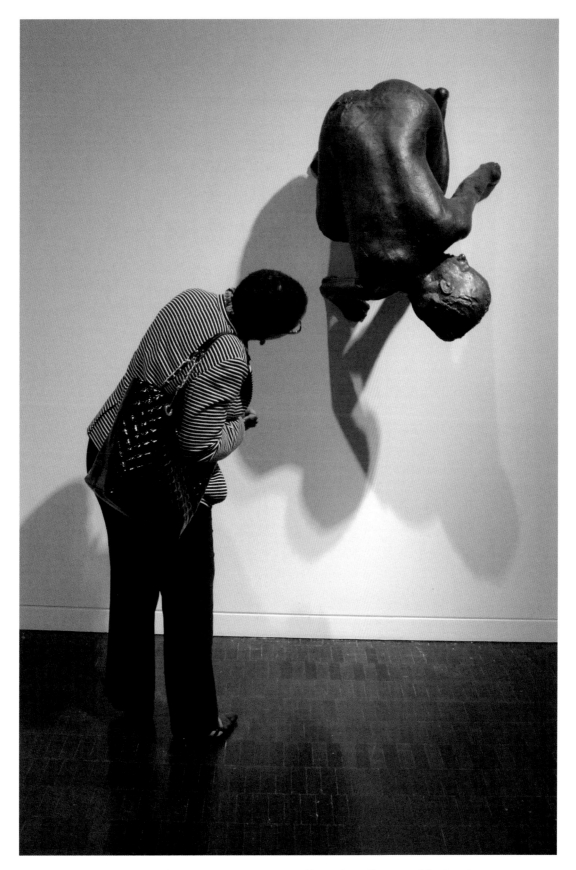

Kiki Smith, *Lilith* (1994), Contemporary Jewish Museum, San Francisco (from the collection of the San Francisco Museum of Modern Art)

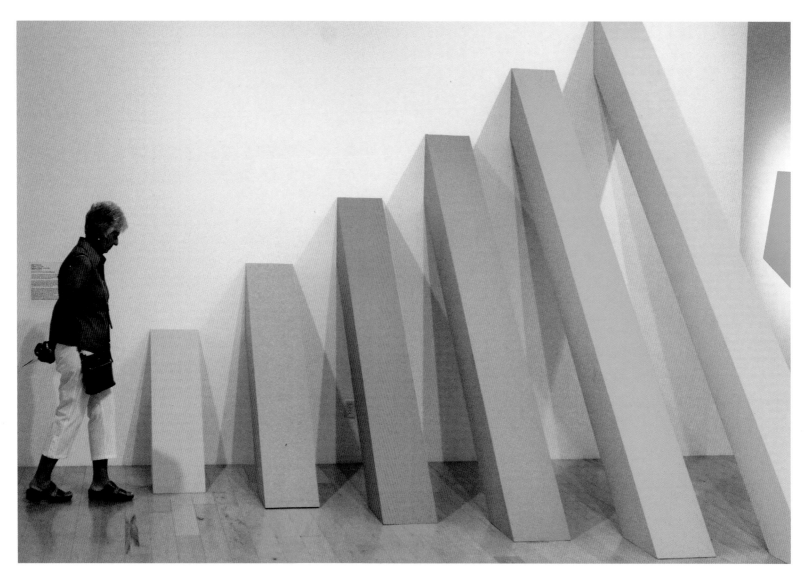

Judy Chicago, *Rainbow Pickett* (1965–2004), Palm Springs Art Museum

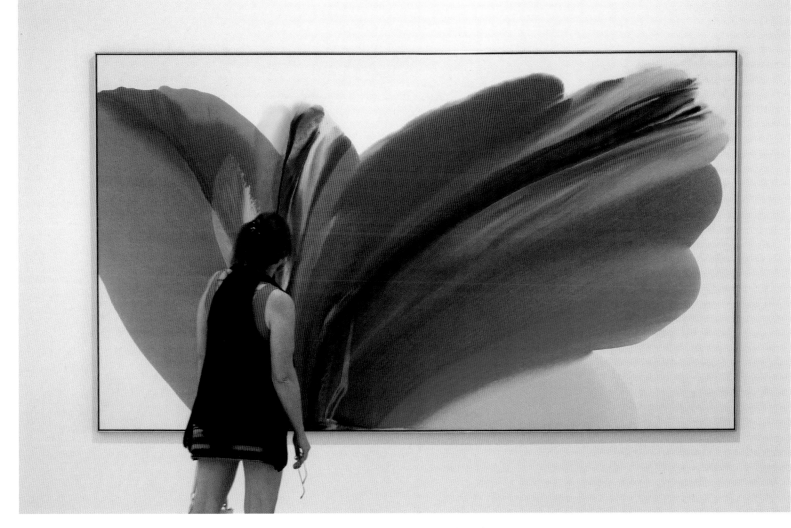

Paul Jenkins, *Phenomena Wind Off Big Sur* (1975), Palm Springs Art Museum

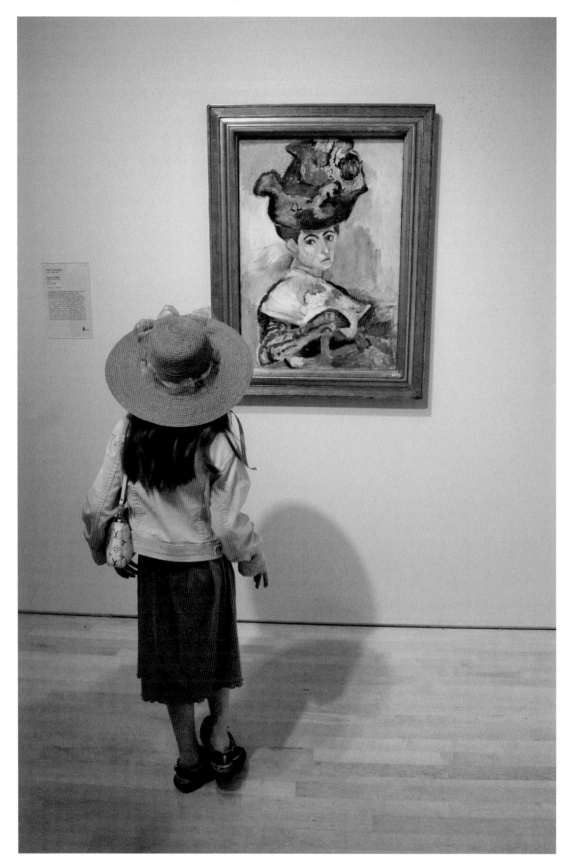

Henri Matisse, *La femme au chapeau* (1905), San Francisco Museum of Modern Art

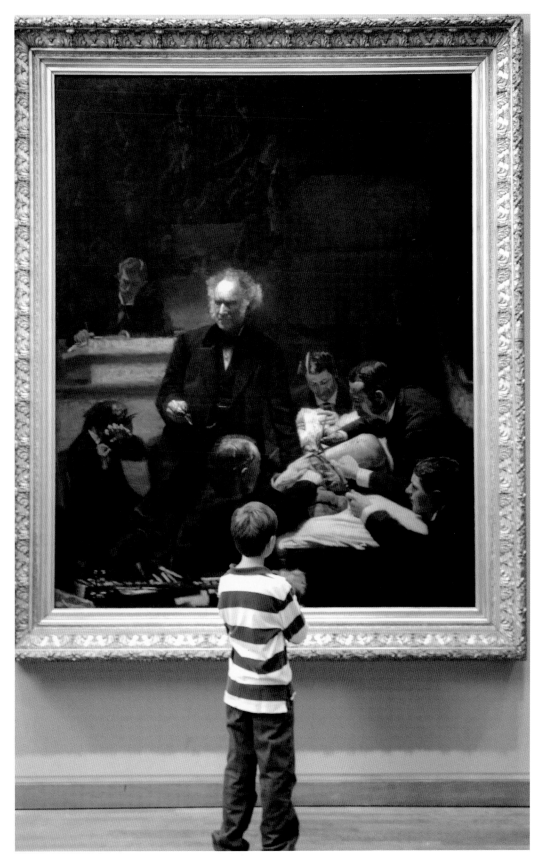

Thomas Eakins, *The Gross Clinic* (1875), Philadelphia Museum of Art

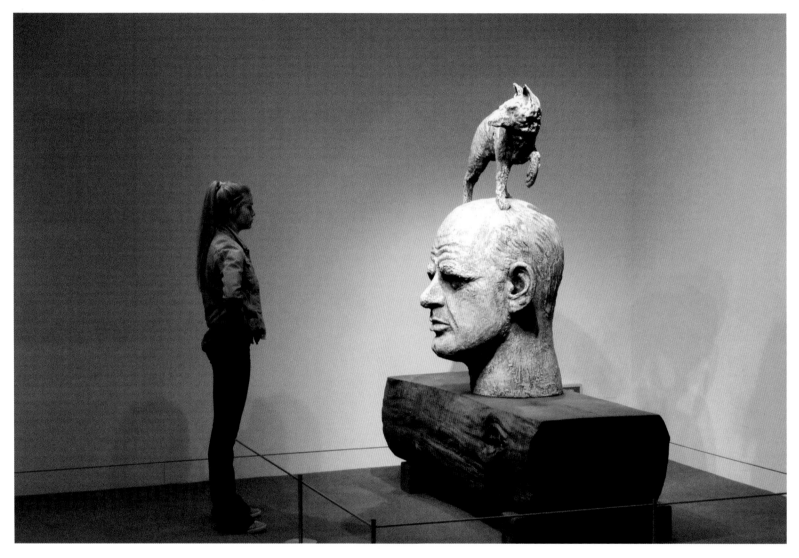

Robert Arneson, *Wolf Head* (1989), Oakland Museum of California

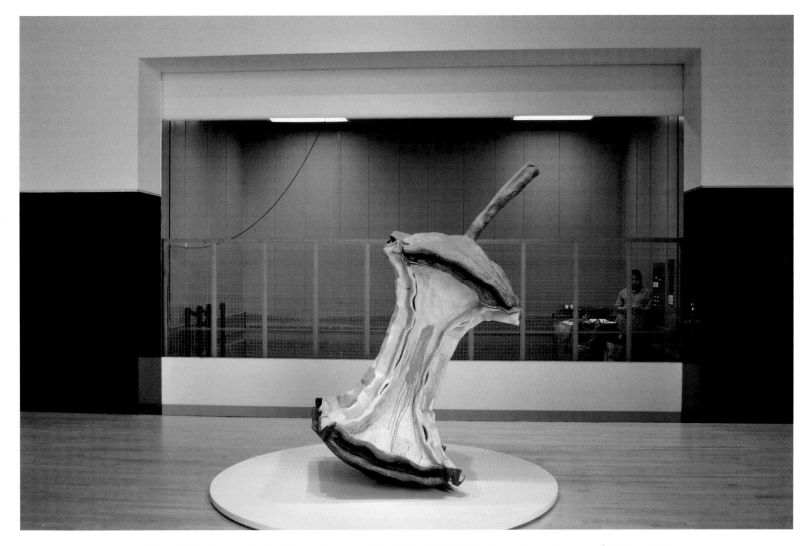

Claes Oldenburg and Coosje van Bruggen, *Apple Core* (1992), San Francisco Museum of Modern Art

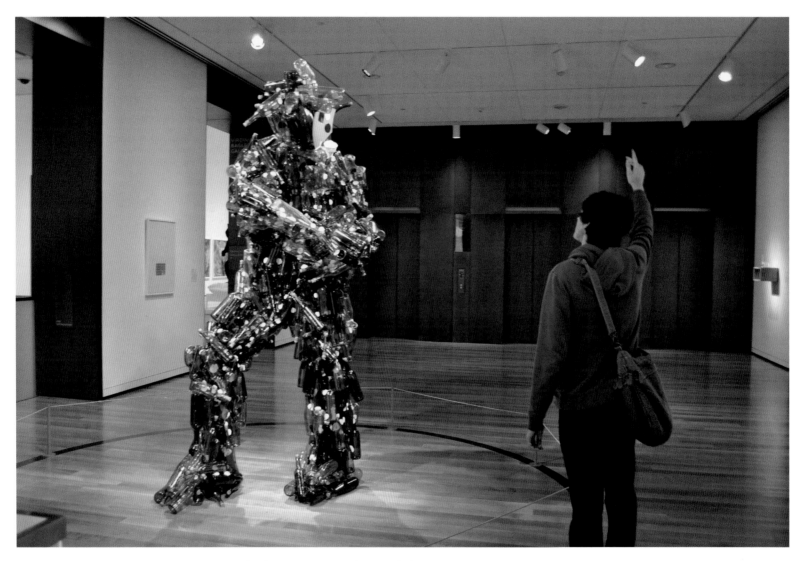

Jerry Pethick, *Le Semeur/Sunlight and Flies* (1984–2002), Seattle Art Museum

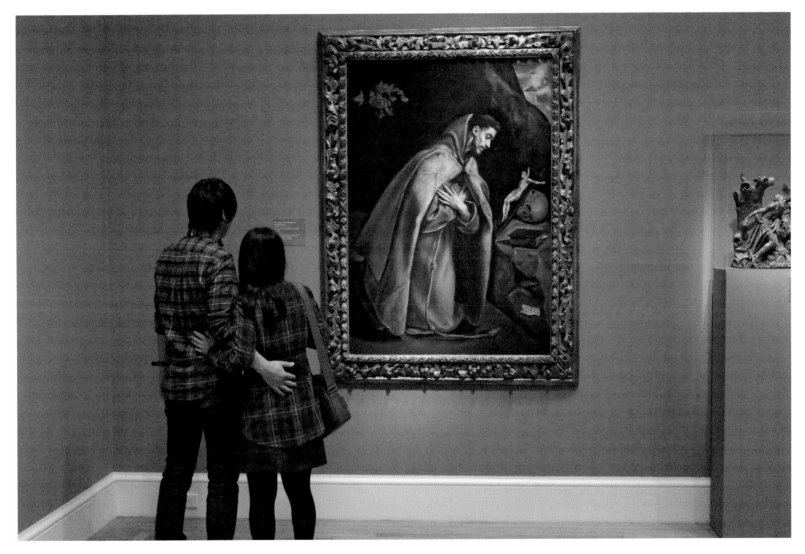

El Greco, *St. Francis Venerating the Crucifix* (1595), Legion of Honor, Fine Arts Museums of San Francisco

AFTERWORD

Richard Nagler

I can't remember going to an art museum on my own until I was in my senior year in college. At the University of Pennsylvania I was on a strictly academic track, but I started dating a student at a nearby art school and that changed my priorities. I wasn't living far from the Philadelphia Museum of Art, and I started to drive up that glorious hill to the museum quite often. The museum was rarely crowded, and parking behind the building was never a problem, so I became a regular. I wasn't a photographer then, and photography wasn't allowed in the museum galleries anyway, but I realized that you were allowed to draw in front of the paintings and the museum guards were very accommodating to people who lingered and made sketches. I started to draw and eventually I did a few paintings from those drawings.

When I moved to Cambridge after graduation in 1969, I continued this routine at the Boston Museum of Fine Arts. The museum was open late on Thursday nights, and I would bicycle down Massachusetts Avenue, over the Charles River, and continue my infatuation with art and museums. In Philadelphia I had fallen under the spell of Thomas Eakins. In Boston, it was John Singer Sargent who captured my attention.

I moved to Oakland, California, in the early 1970s. My romance with museums soon carried over to the Oakland Museum and the San Francisco Museum of Art. In those years, the Oakland Museum was open late on Sundays and there was often a pianist providing background music for a stroll through the galleries. The great Bay Area figurative painters became the focus for me there: David Park, Richard Diebenkorn, Nathan Oliveira, and Elmer Bischoff. But what truly astonished and inspired me in Oakland was that, for the first time, I saw photography as an equal part of the exhibitions. Photography wasn't just confined to a small back gallery. Rather, it was accepted and included as another of the visual fine arts. Photographs were prominently displayed alongside the paintings and sculptures. I got my first exposure to the California legends: Ansel Adams, Edward Weston, Ruth Bernhard, Imogen Cunningham, and Dorothea Lange, among others.

Around that same time, I first began dabbling in photography myself. Coincidentally, my brother was becoming a commercial photographer at the time, and he was very generous with advice and equipment. I began using photography as an aid to some oil paintings I was making, but I soon found that the color slides I was taking were exceptionally beautiful on their own, especially when I projected the slides. Quickly the painting took a backseat to the photography.

Photography soon became a genuine passion for me. In the back of my mind, I started to make images that I kept in a file I called "parallelographs." I was always looking for situations where someone would mirror or echo a scene or object behind them. One of the earliest results of this preoccupation was

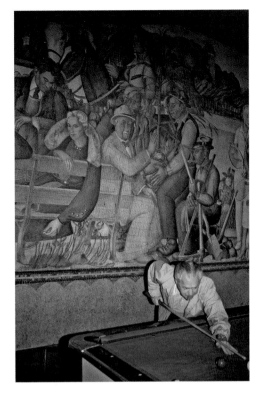

Beach Chalet, April 1975

manifested in a photograph I took at the Beach Chalet on the Great Highway in San Francisco in April 1975.

A man was playing pool while blending into a 1930s WPA mural behind him. On a whim, I showed this picture at the San Francisco Photo Fair in 1978. I had never shown a photograph to the public before, and there were dozens and dozens of photographers gathered in Washington Square Park showing thousands of photographs. To my surprise and delight, the Beach Chalet image won the grand prize in photography.

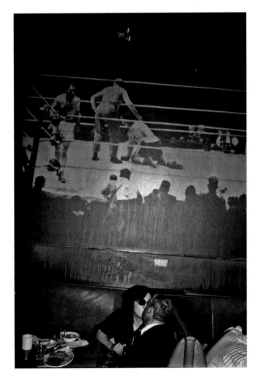

Breen's, May 1979

I took the following image in May 1979 at the closing night of an old bar and restaurant called Breen's on Third Street in San Francisco.

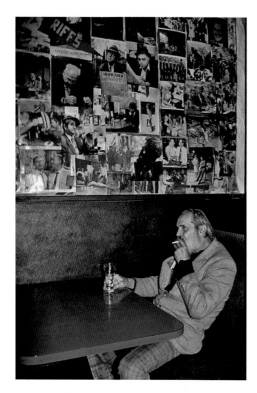

In June of 1979, I took the following photograph at Jerry and Johnny's, another old bar just up the street from Breen's, in that rough neighborhood called South of Market. I had been documenting this neighborhood, which was about to undergo the redevelopment that would lead to a new cultural center in the city.

These photographs reinforce to me that my later photographs in art museums were quite consistent with my earlier "parallelographs."

Jerry and Johnny's, June 1979

I was still going to museums and galleries whenever I could, and I found that I was always as fascinated by the people there as I was by the art. I was still taking slides, but the color transparency film I used was very slow, so I would often have to use a flash. I took this photograph of a young girl taking notes in front of a sculpture by John De Andrea at an art gallery in Paris in October 1985.

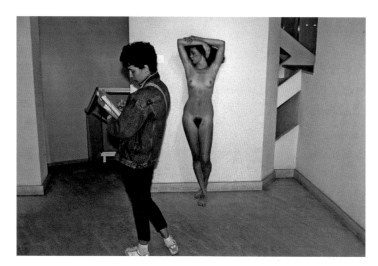

I was struck by the parallels between her face and that of the nude sculpture behind her.

Sculpture by John De Andrea, Paris, October 1985

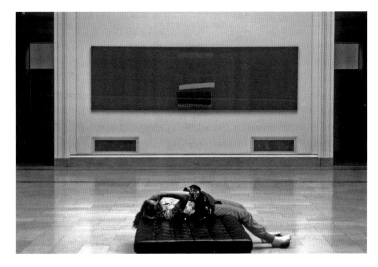

San Francisco Museum of Art, July 1983

In art museums at the time, it was strictly forbidden to take photographs, but occasionally I would sneak a picture in before the guards arrived and read me the riot act. The following image was taken at the old San Francisco Museum of Art in July 1983. The colors were just so perfect that I was willing to risk the wrath of the guards.

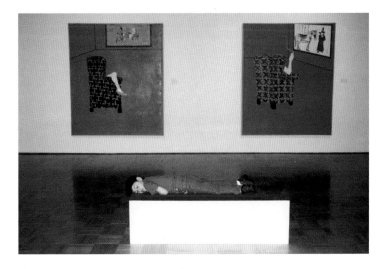

Paintings by Joan Brown,
Oakland Museum of California, December 1988

In December 1988, I was able to sneak this picture at an exhibition of paintings by Joan Brown at the Oakland Museum. Firing a flash drew lots of attention and disapproval from the guards, but how could I pass this up?

It wasn't until many years later that I first realized that the rules were changing. I was in New York at the Museum of Modern Art in August 2007. I noticed a few people taking their cameras out and snapping pictures in the museum. I asked a guard what was going on and was informed that MoMA was now permitting photography in their permanent collection as long as tripods and flashes were not used.

I was in the process of switching to digital from film photography and I found that I could take consistently good images in museums with a handheld digital camera. Digital imaging was much better suited to low-light situations and was much faster and sharper than film. I captured the beautiful young girl pausing in front of *Les Demoiselles d'Avignon,* which is on the cover of this book, on that August day at the Museum of Modern Art. I was hooked.

Other museums around the country began to loosen their rules. Cameras and cell phones with picture-taking capability began to appear more and more frequently in the galleries. People had started taking pictures of their favorite artworks, perhaps to use as screen savers or wallpaper for their smartphones and computers. But I also noticed a lot of people were posing for their friends and family in front of great works of art.

Famous paintings were now like great architecture and design. People wanted to be photographed in front of famous art just as they posed in front of the Eiffel Tower or the Golden Gate Bridge. Art became an additional cultural marker in our lives. It wasn't enough to just see the *Mona Lisa* in person; now viewers were able to document themselves in front of the great work of art.

I enjoyed observing and recording all this activity. With this newfound freedom I began to photograph in museums as often as I could. I looked for the parallels between the viewer and the art on the walls. I had found the perfect balance between my love for observing people and my love for art: *the art of looking.*

In these photographs, I am hoping to make new layers of art upon the old. I am inspired by the human dance that takes place in front of great works of art and the accidental and beautiful juxtapositions that can occur. Taking these photographs is a great way for me to linger in front of great art just as I was able to do so many years before with a pencil and a sketchpad.

There is an unmistakable connection between all the great paintings I have seen by Sargent, Eakins, the California figurative artists, my early

"parallelographs," and my three previous books of photography. What links it all together for me is a love and respect for the human figure. I have been observing and photographing people for over forty years. It is my fervent hope that the photographs I take are done with the deepest respect for the individuals who are photographed and that my observations are accepted as a respectful recording of a beautiful, important, and meaningful moment in time. If and when I photograph someone's presence, if even for one thirtieth, sixtieth, or one hundred and twenty-fifth of a second, I hope it is understood that I am doing so with great reverence for that person and with the hope that I am creating art that captures the serendipitous and accidental beauty we can create as we go about our lives on this planet.

This book enables me to present to you, the viewer and reader, many of the pleasures that *looking at art* has given me over the years. I am grateful to the museums and staff that serve such an important civic function. I thank the donors, collectors, and artists who enrich our cultural lives and without whose generosity and talents this book would not be possible.

I am blessed to have found a supportive home for my photography at Heyday. Photography can be a lonely business, but when you get to work with Malcolm Margolin, Gayle Wattawa, Diane Lee, and all the other brilliant staffers at Heyday, suddenly photography becomes a wonderful, memorable collaboration. It's like going from a solo, quiet walk in the woods to a boisterous square dance with music and smiles and the joy of dancing with many wonderful partners.

But I am particularly grateful to the lovely, interesting, intelligent, and engaged people I have photographed who attend museums and make their own great art as they do so. I thank them all for allowing me to surreptitiously layer the beauty of the human experience upon the backdrop of the amazing artworks that are our common human heritage. And I thank all the anonymous people who have let me invade a private moment in their lives to create the beautiful juxtapositions I have captured over the years in our museums while *looking at art*.

Richard Nagler
Berkeley, California
July 2013

Richard Nagler has been a fine art photographer for almost forty years. This is his fourth book of photography, following the critically acclaimed works *My Love Affair with Miami Beach* (Simon and Schuster, 1990), *Oakland Rhapsody: The Secret Soul of an American Downtown* (North Atlantic Books, 1995), and *Word on the Street* (Heyday, 2010). His photographs are included in many prominent public and private collections and have been viewed in many notable publications, including the *New York Times,* the *Los Angeles Times,* the *Wall Street Journal,* the *San Francisco Chronicle, Playboy Magazine,* and *Artforum International.* He is represented by George Krevsky Gallery, San Francisco.

Malcolm Margolin is the founder and publisher of Heyday, a nonprofit, independent publishing house and cultural institution in Berkeley, California. A prolific author and editor on California's many cultures, history, and nature, Margolin's books include *East Bay Out, The Way We Lived, The Earth Manual,* and *Native Ways.* He has been the recipient of many prestigious awards, including the Chairman's Commendation from the National Endowment for the Humanities and the Cultural Freedom Award from the Lannan Foundation.

HEYDAY

About Heyday

Heyday is an independent, nonprofit publisher and unique cultural institution. We promote widespread awareness and celebration of California's many cultures, landscapes, and boundary-breaking ideas. Through our well-crafted books, public events, and innovative outreach programs we are building a vibrant community of readers, writers, and thinkers.

Thank You

It takes the collective effort of many to create a thriving literary culture. We are thankful to all the thoughtful people we have the privilege to engage with. Cheers to our writers, artists, editors, storytellers, designers, printers, bookstores, critics, cultural organizations, readers, and book lovers everywhere!

We are especially grateful for the generous funding we've received for our publications and programs during the past year from foundations and hundreds of individual donors. Major supporters include:

Anonymous (5); Alliance for California Traditional Arts; Arkay Foundation; Judy Avery; James J. Baechle; Paul Bancroft III; Richard and Rickie Ann Baum; BayTree Fund; S. D. Bechtel, Jr. Foundation; Jean and Fred Berensmeier; Berkeley Civic Arts Program and Civic Arts Commission; Joan Berman; John Briscoe; Lewis and Sheana Butler; California Civil Liberties Public Education Program; Cal Humanities; California Indian Heritage Center Foundation; California State Parks Foundation; Keith Campbell Foundation; Candelaria Fund; John and Nancy Cassidy Family Foundation, through Silicon Valley Community Foundation; Charles Edwin Chase; Graham Chisholm; The Christensen Fund; Jon Christensen; Community Futures Collective; Compton Foundation; Creative Work Fund; Lawrence Crooks; Nik Dehejia; Frances Dinkelspiel and Gary Wayne; The Durfee Foundation; Earth Island Institute; The Fred Gellert Family Foundation; Fulfillco; The Wallace Alexander Gerbode Foundation; Nicola W. Gordon; Wanda Lee Graves and Stephen Duscha; David Guy; The Walter and Elise Haas Fund; Coke and James Hallowell; Steve Hearst; Cindy Heitzman; Historic Resources Group; Sandra and Charles Hobson; Donna Ewald Huggins; Humboldt Area Foundation; JiJi Foundation; The James Irvine Foundation; Claudia Jurmain; Marty and Pamela Krasney; Robert and Karen Kustel; Guy Lampard and Suzanne Badenhoop; Christine Leefeldt, in celebration of Ernest Callenbach and Malcolm Margolin's friendship; Thomas Lockard; Thomas J. Long Foundation; Judith and Brad Lowry-Croul; Michael McCone; Nion McEvoy and Leslie Berriman; Giles W. and Elise G. Mead Foundation; Michael Mitrani; Moore Family Foundation; The MSB Charitable Fund; Richard Nagler; National Endowment for the Arts; National Wildlife Federation; Native Cultures Fund; The Nature Conservancy; Nightingale Family Foundation; Northern California Water Association; Ohlone-Costanoan Esselen Nation; David Plant; The David and Lucile Packard Foundation; Panta Rhea Foundation; Alan Rosenus; The San Francisco Foundation; Greg Sarris; William Somerville; Martha Stanley; Radha Stern, in honor of Malcolm Margolin and Diane Lee; Roselyne Chroman Swig; Swinerton Family Fund; Sedge Thomson and Sylvia Brownrigg; TomKat Charitable Trust; Michael and Shirley Traynor; The Roger J. and Madeleine Traynor Foundation; Lisa Van Cleef and Mark Gunson; Patricia Wakida; John Wiley & Sons, Inc.; Peter Booth Wiley and Valerie Barth; Bobby Winston; Dean Witter Foundation; The Work-in-Progress Fund of Tides Foundation; and Yocha Dehe Wintun Nation.

Getting Involved

To learn more about our publications, events, membership club, and other ways you can participate, please visit www.heydaybooks.com.